HOW TO DRAW
COMIC BOOK
BAD GUYS
AND GALS
CHRISTOPHER HART

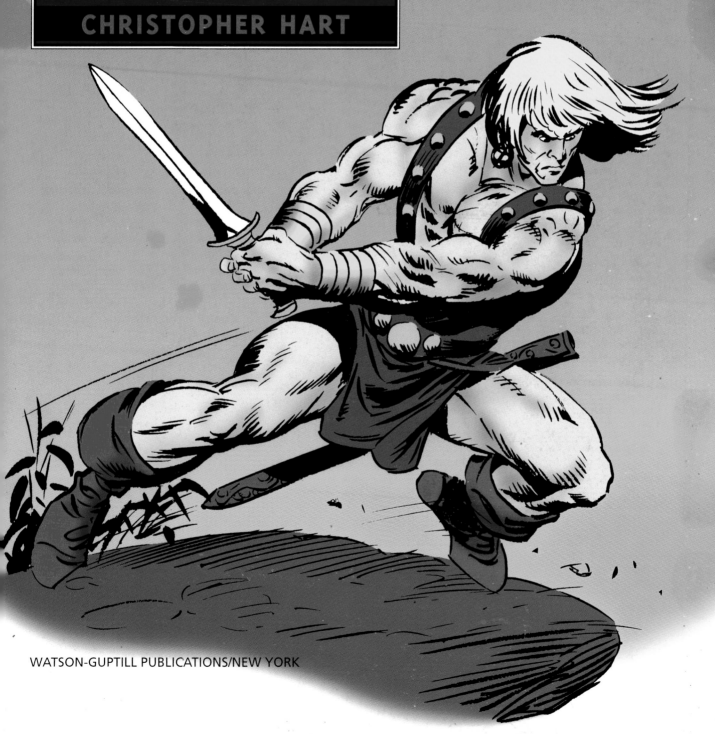

WATSON-GUPTILL PUBLICATIONS/NEW YORK

For anyone who loves to draw

Senior Editor: Candace Raney
Project Editor: Alisa Palazzo
Designer: Bob Fillie, Graphiti Design, Inc.
Production Manager: Ellen Greene

First published in 1998 by Watson-Guptill Publications,
a division of VNU Business Media, Inc.,
770 Broadway, New York, NY 10003
www.watsonguptill.com

Library of Congress Cataloging-in-Publication Data
Hart, Christopher.
 How to draw comic book bad guys and gals / Christopher Hart.
 p. cm.
 Includes index.
 ISBN 0-8230-2372-9 (pbk.)
 1. Cartooning—Technique. 2. Comic books, strips, etc.—Technique.
3. Comic strip characters. I. Title.
NC1764.H365 1998
741.5—dc21 98-6411
 CIP

Printed in Singapore

First printing, 1998

6 7 8 9/06 05 04 03 02

I'd like to thank those tireless
people who work night and day
to make the world safe for
cartoonists like you and me—
my publishers: Glenn Heffernan,
Candace Raney, Harriet Pierce,
Alisa Palazzo, Bob Fillie, Ellen
Greene, and Hector Campbell.

Contributing artists:
Derec Aucoin
Tom Grindberg
Chuck Wojtkiewicz
Howard Porter
Rich Faber

CONTENTS

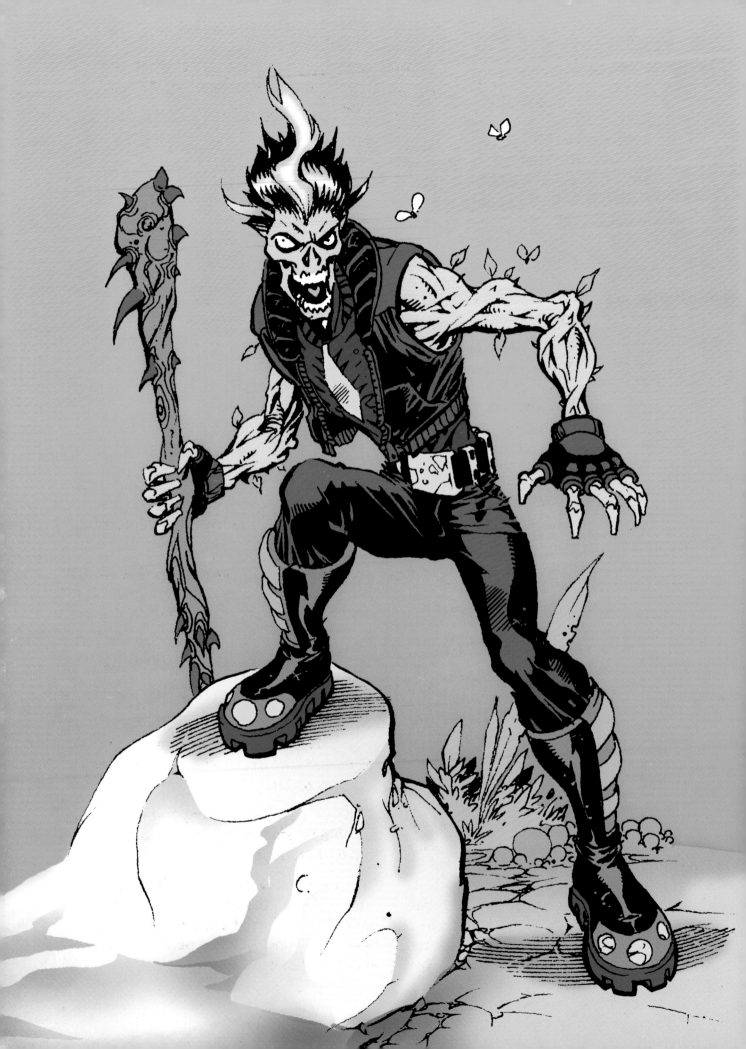

INTRODUCTION

Bad guys (and gals) rule. These charismatic egomaniacs often overshadow the popularity of the heroes against whom they're pitted. Without bad guys, there would be no heroes, no battles, no story. Comic book heroes would be relegated to extolling the virtues of recycling. Without bad guys, what would heroes fight against? Global warming? The stature of any hero is measured against the awesome destructive capabilities of the bad guy he, or she, is facing. Bad guys have always been the key to great storytelling. Remember *Star Wars,* the most successful film of all time? Who is the more memorable character? The evil Darth Vader? Or that Milquetoast, Luke Skywalker? Isn't it time you got evil?

Bad guys are fun to draw (more fun than heroes, because you can push the envelope as far as you want). They can be quirky, insane, diabolical. They aren't confined by rules of decency or loyalty. Bad guys make up the rules as they go along! This book will show you how to draw the latest styles of bad-guy characters appearing in comics today. It isn't a "trace me" book, but a step-by-step guide that will teach you how to really draw so that you can not only draw the characters appearing in these pages, but go on to design your own, original bad guys.

This book is also about drawing *bad gals.* Bad gals are the most alluring women in the comics. Most books on comic-book art only show you how to draw the girl-next-door type, but she never got anyone's blood boiling the way these bad gals do. Bad gals are an essential part of any comic book artist's repertoire.

So, here are just a few of the things you'll learn in this book:

■ An easy method to "quick check" the proportions of the head so that you can instantly adjust your drawings to always look right

■ How to draw the body from all the angles that comic book artists use—not just from the front, back, and side poses demonstrated in other books

■ Short cuts to anatomy (there are over 500 muscles in the human body, but you only need to know a few key muscle groups to draw powerful comic book characters)

■ How to change a good guy into a bad guy

■ How to use light and shadow to create dramatic images

■ Character "acting": the secrets for getting great performances out of your comic book characters

■ Tips on visual storytelling and on creating fearsome costumes, dynamic compositions, and backgrounds for bad guys

Remember, no one draws perfectly every time. Not even the pros. It takes practice, patience, and lots of erasers. 'Nuff said. Ready for launch? Grab a pencil and paper, and let's blast off!

GETTING STARTED

Before you begin to draw bad guys and gals, you first need to get acquainted with the basic proportions of the head. Once you know the basics, you'll be able to transform regular or idealized heads into the corrupt, evil enemies of society that you admire so much. You're pretty sick, you know that?

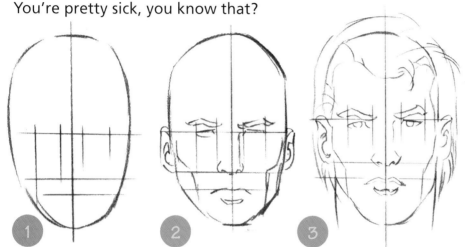

Drawing the Head

1. Always start by drawing the basic head shape first, then add more detail as you continue. The head is not round, and it's not a perfect oval, either. It's egg shaped. Sketch in a vertical guideline to divide the head evenly in half. Also sketch in some horizontal guide-lines to indicate the placement of the eyes, nose, and mouth. Notice that the eyes fall in the middle of the head, not near the top, and that the nose is approximately one eye length wide. Add some short, evenly spaced vertical lines, indicating where the edges of the eyes will fall.

2. The tops of the ears are at the same level as the eyebrows, and the bottoms are even with the bottom of the nose. By keeping these things in mind, you can check your drawings when something doesn't look quite right and make simple adjustments.

3. The hairstyle rests on top of the scalp. A man's neck is always thick and strong in comics. Also note the articulation of the cheek bones.

4. Work with breezy, fluid strokes. Don't press too hard on your pencil.

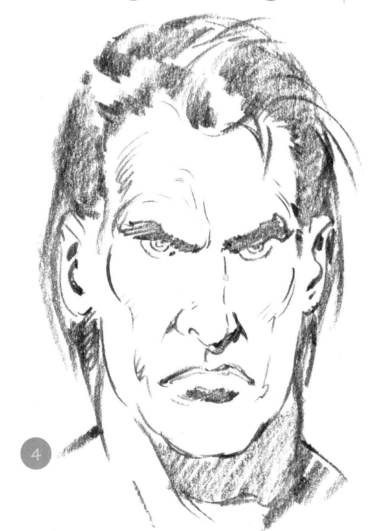

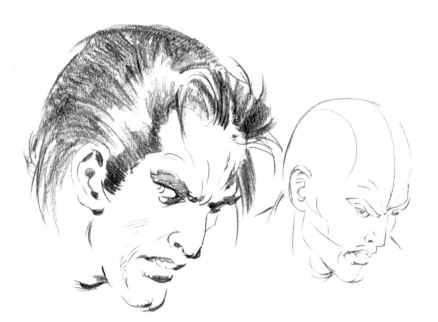

Head Tilts

Comic book characters fly, leap, tumble, and dive. You've got to be able to capture their poses from many different angles. The front view is great for introducing a character to the reader, or for reaction shots, but to be a full-fledged comic book artist, you're going to need a bigger arsenal than that. Here are your weapons.

3/4 VIEW—HIGH ANGLE
A 3/4 view means that 3/4 of the character's face is turned toward the reader, while 1/4 of the face is turned away from the reader. It's a pleasing angle because it offers a good view of the character, but with more depth than a flat front view. A high angle means that you, the artist, draw the character as if you were positioned above it, looking down at it.

PROFILE
Also referred to as the side view, the profile is the easiest pose to draw because there's no foreshortening involved, and you're only drawing half of the face. It makes for a good, hard expression. However, to create a more revealing look at a character, you'll need to use a fuller shot—either a 3/4 or front view.

FRONT VIEW—LOW ANGLE
This is a head-on shot, but one that looks up at the character. Note how the foreshortening causes the chin to appear longer and the forehead shorter.

FRONT VIEW— HIGH ANGLE
A high angle means that you draw the character as if you were positioned above it, looking down at it. Note how the foreshortening reverses the proportions of the low-angle front view: here, the high angle causes the forehead to appear longer and the chin shorter.

7

The Female Head

When drawing the female head, use lines with gentler curves—not the sharp angles that you would find on a man. This is especially true when drawing the bridge of the nose and the chin. The cheekbones of a woman can be defined, but they don't travel down the face to create creases around the mouth as they do on a man. In general, there are fewer creases and expression lines on women's faces.

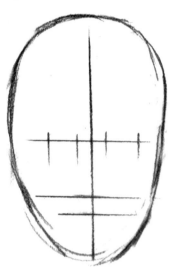

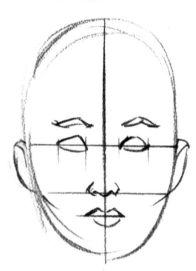

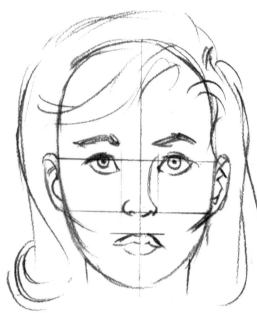

Start with an egg shape, but make the chin area narrower than it would be on a man. Divide the head with a vertical line down the middle. Then, sketch in the horizontal guidelines for the levels of the eyes, nose, and mouth. Draw some evenly spaced, vertical lines to indicate where the eyes will fall.

Sketch the features in place.

When drawing female eyebrows, make them arch higher than those of a man. Also, the nose should be less defined than it is on a man. In fact, some artists leave out the bridge of the female nose altogether and just draw the tip of the nose and the nostrils. The lips, especially the upper lip, should be larger.

Add the hair, which should fall loosely in front and behind the shoulders, unless it's a sharp, stylized cut.

Head Tilts for Women

Showing the underside of a woman's jaw creates an alluring pose. It can be seen only in a low angle. The high angle conveys a moodier attitude.

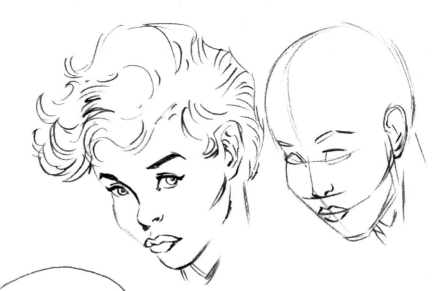

3/4 VIEW—HIGH ANGLE
Note the pouty expression, best shown from a high angle, as her eyes peek out from under heavy eyelashes.

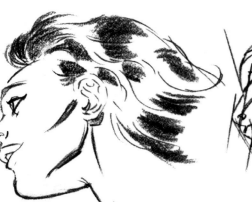

PROFILE—LOW ANGLE
Showing the underside of the jaw, as in this profile from a low vantage point, is an especially effective angle for showing off the beauty of attractive women.

3/4 VIEW—HIGH ANGLE
A reflective mood is best shown from a high angle.

3/4 VIEW—LOW ANGLE
An outward-curving neck is also an attractive look that can be drawn from a low angle in which the head tilts back.

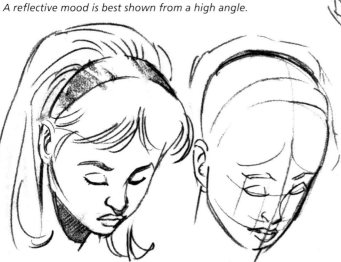

9

Men's Features

EYES

Bad guys do a lot of frowning, even when they smile. It's part of the job requirement. As the eyebrow presses down on the eye to create a frown, the shape of the eye narrows. In a severe frown, the eyebrow conceals the top eyelid altogether. Be sure to use a heavier line to draw the top eyelid than you do to draw the bottom. And, note that the shape of the eye tapers most sharply toward the ear.

EARS

Most people can draw the outer shape of the ear fairly easily, and the flap over the hole to the ear canal is no big deal either. The part that causes anxiety is the pattern of cartilage inside the ear, surrounding the hole. Practice these drawings enough times and you'll be able to draw ears in your sleep.

NOSE

The bridge of the nose is made of bone. About half way down, it indents to some degree as the bone changes to cartilage. The nostrils are higher up than the tip of the nose.

MOUTH

On a man, the top lip is thin and the bottom one is thick. Some artists like to add a shadow under the bottom lip. Don't draw each individual tooth, unless it's for a ferocious expression. Keep in mind that the middle of the top lip has an indentation that dips slightly, while the middle of the bottom lip has an indentation that rises slightly.

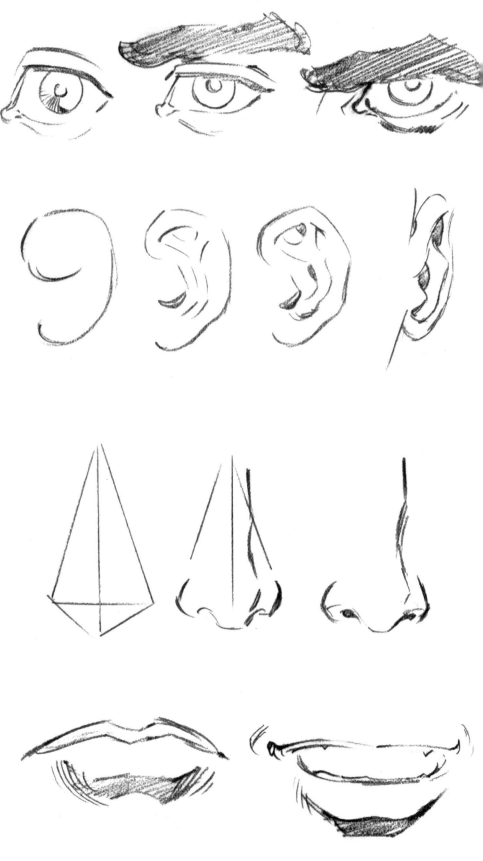

Women's Features

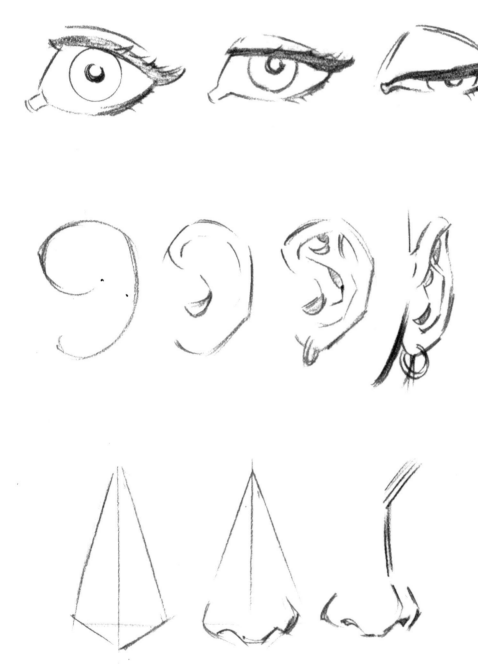

EYES
The upper eyelid must be very dark—remember, she's been applying that eyeliner before she even stepped out of the bathroom in the morning. Show the eyelashes, but bunch them together.

EARS
This feature is pretty much the same deal as with a guy, only smaller and with earrings.

NOSE
Remember how we gave a little indentation to the bridge of the nose on a guy's face? Well, forget it with a woman. It looks masculine. In fact, as I said before, many artists prefer to leave out the bridge of the nose altogether on women, preferring only to indicate the nostrils. It's a crazy, crazy world, man.

MOUTH
The upper lip is composed of three masses; the lower lip is composed of only two. On a woman, as opposed to a man, the upper lip is thick—sometimes even thicker than the bottom lip. This creates a pouty appearance.

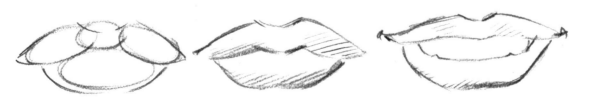

Bad Guy Expressions

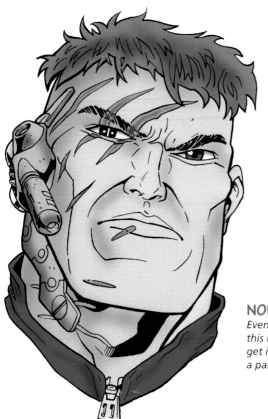

Whereas a good guy may have carefree moments, a bad guy has inner turmoil that gives him an uneasy, menacing countenance all the time. You've got to be able to draw your characters in a bunch of different expressions so that they become three-dimensional, interesting, and complex bad guys.

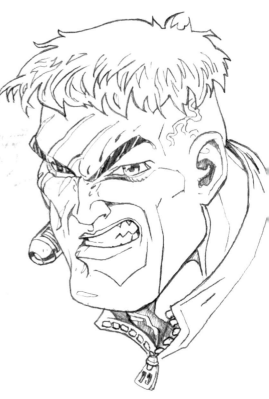

NORMAL EXPRESSION
Even with a laid back expression, this isn't someone I'd want to get into an argument with over a parking space.

THE SNARL
Something's really bugging this guy big-time, and in a moment, he's going to explode into action.

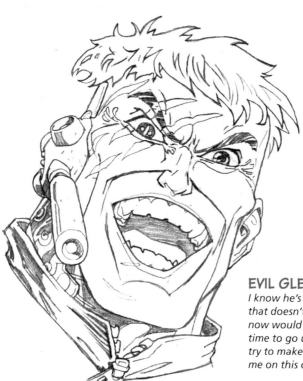

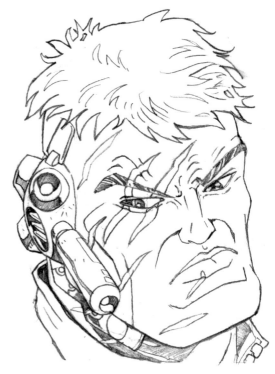

EVIL GLEE
I know he's smiling, but that doesn't mean that now would be a good time to go up to him and try to make friends. Trust me on this one.

TROUBLED
Problems figuring out how to annihilate a planet and stuff like that can get a bad guy down.

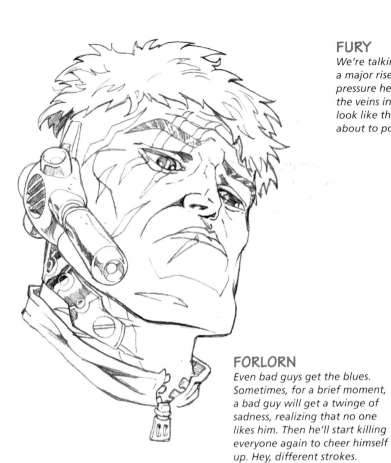

FURY

We're talking about a major rise in blood pressure here. Even the veins in his neck look like they're about to pop.

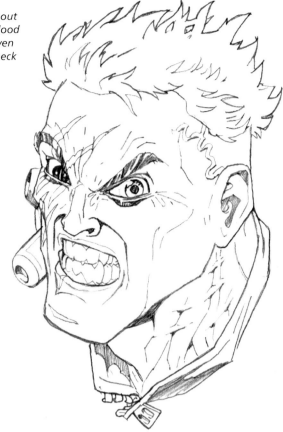

FORLORN

Even bad guys get the blues. Sometimes, for a brief moment, a bad guy will get a twinge of sadness, realizing that no one likes him. Then he'll start killing everyone again to cheer himself up. Hey, different strokes.

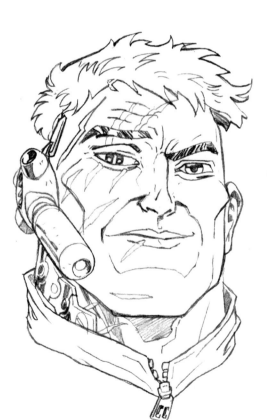

COCKSURE

What's a bad guy, if not confident? I mean, you blow up enough buildings and, after a while, you come to realize that, yes, you are good at something.

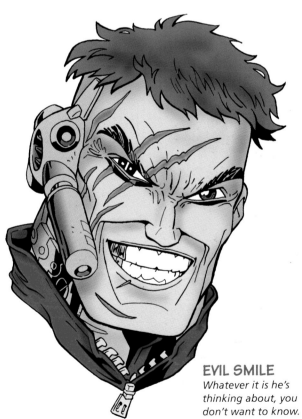

EVIL SMILE

Whatever it is he's thinking about, you don't want to know.

Only Bad Gals Have Face Tattoos

My rule of thumb is: Never date a girl who has a tattoo on her face or whose brother goes by the nickname Animal.

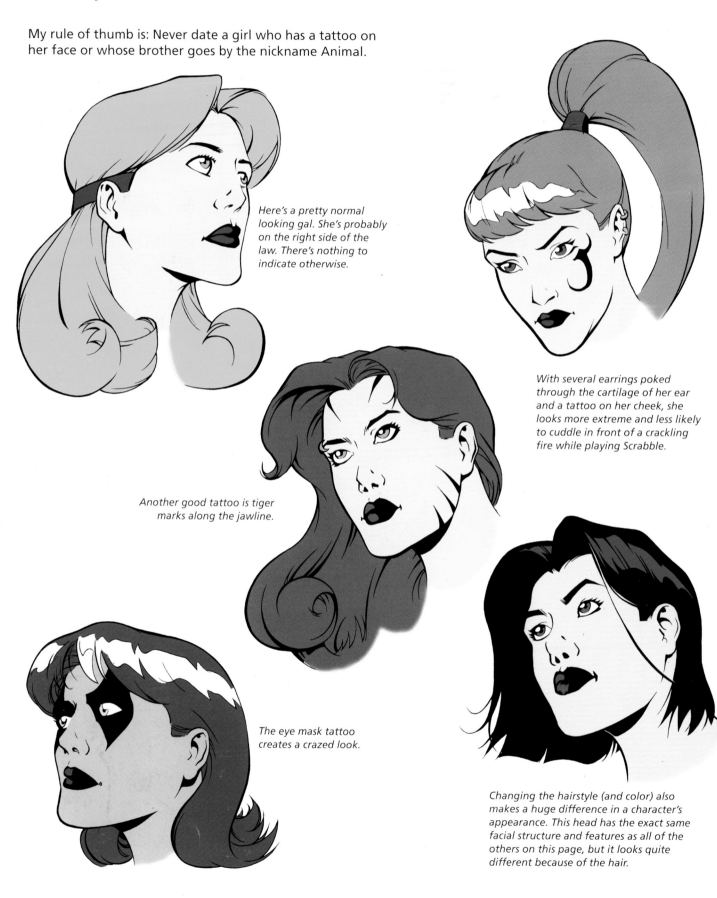

Here's a pretty normal looking gal. She's probably on the right side of the law. There's nothing to indicate otherwise.

With several earrings poked through the cartilage of her ear and a tattoo on her cheek, she looks more extreme and less likely to cuddle in front of a crackling fire while playing Scrabble.

Another good tattoo is tiger marks along the jawline.

The eye mask tattoo creates a crazed look.

Changing the hairstyle (and color) also makes a huge difference in a character's appearance. This head has the exact same facial structure and features as all of the others on this page, but it looks quite different because of the hair.

Drawing Evil Hands

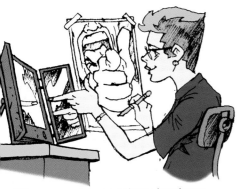

Drawing hero hands is boring. Five fingers and you're done. But, when you draw bad guys, you have the opportunity to design hands that reflect the physical powers and warped world view of your villain. Here are some prime examples.

When you come up against a hand pose that's got you stumped, strike that pose with your hand, and rotate it in front of a mirror to get an understanding of the form from all angles.

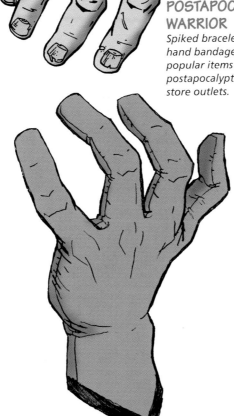

POSTAPOCALYPTIC WARRIOR
Spiked bracelets and hand bandages are popular items at most postapocalyptic clothing store outlets.

EVIL SCIENTIST
Why scientists always have to be evil in the comics, I'll never know, but that's the way it is. They're also usually bony and frail.

WITCHY WOMAN
Long fingernails and elaborate, creepy jewelry help to cast a woman in the role of an enchantress of the occult.

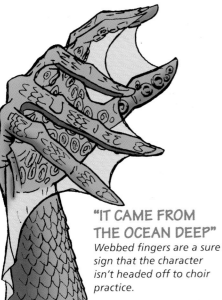

"IT CAME FROM THE OCEAN DEEP"
Webbed fingers are a sure sign that the character isn't headed off to choir practice.

MUTANTS
Didn't your mother ever tell you not to play with opened canisters of nuclear waste? Now look what happened! Mutant hands can have an odd number of fingers, as with this guy, who has three instead of four. Be sure to draw them in a realistic style; if you make the hand cartoony, it's going to look like a normal hand in an animated cartoon, which typically has only three fingers and a thumb. You can draw your mutant with seven fingers, three fingers, two, or even just one.

THE CLAW
Anything resembling a lizard is usually an enemy. Anything resembling a lizard with spiked claws is a dangerous enemy.

Basic Muscle Groups

There are over 500 different muscles in the body. You've got to know which ones to exaggerate for comic book characters and which ones to forget about. These are the "show muscles," that is, the muscles that are most apparent.

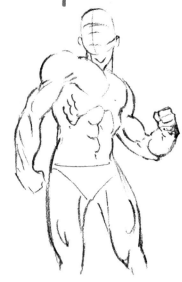

THE CHEST MUSCLES
A flexed chest has horizontal striations across it.

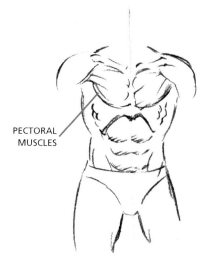

PECTORAL
MUSCLES

CREATING A WIDE GIRTH
The latissimus dorsi muscles add width to the upper body. The "lats," as bodybuilders call them, are back muscles, but you can see them in this front pose. You could toss in a few rippling abdominal muscles, as well. When the arms are raised, the line of the chest travels up the shoulders and curves around the biceps.

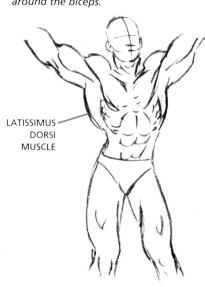

LATISSIMUS
DORSI
MUSCLE

THE SHOULDER MUSCLES
The deltoid (shoulder muscle) is actually made up of three smaller muscles. Together, they form a teardrop shape, the point of which wedges between the biceps and the triceps of the upper arm.

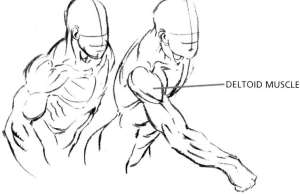

DELTOID MUSCLE

THE BACK
When the body twists, bends, and contracts, the shoulder blades, lats, and deltoids become much more prominent.

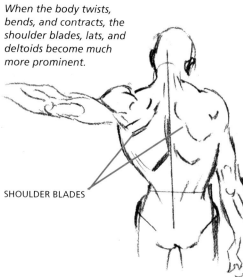

SHOULDER BLADES

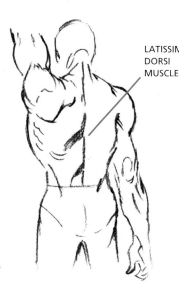

LATISSIMUS
DORSI
MUSCLE

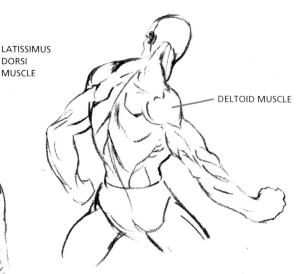

DELTOID MUSCLE

POWERFUL ARMS

The upper arm should have more than just a biceps. The triceps is actually a larger muscle, unless of course, you're a 15-year-old kid who's spent every waking moment doing nothing but curls in his garage. Note the teardrop shape of the deltoid and how it wedges between the biceps and triceps.

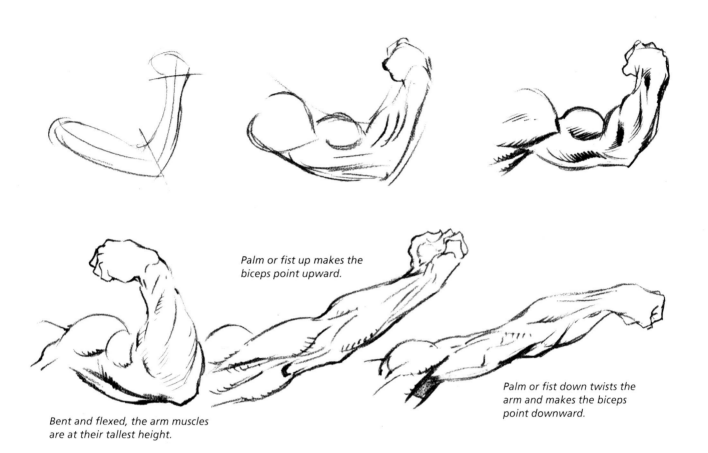

Palm or fist up makes the biceps point upward.

Palm or fist down twists the arm and makes the biceps point downward.

Bent and flexed, the arm muscles are at their tallest height.

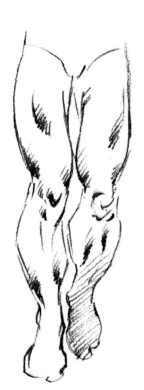
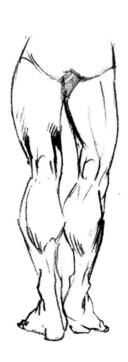
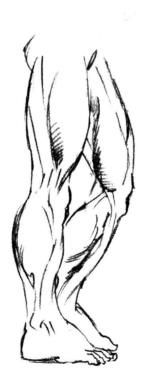

LEGS

The thigh has some of the longest muscles in the body. The leg is not drawn perfectly straight but at a considerable arc. Note how much narrower the leg becomes at the knee before widening out again into large calves.

Turning a Good Guy into a Bad Guy

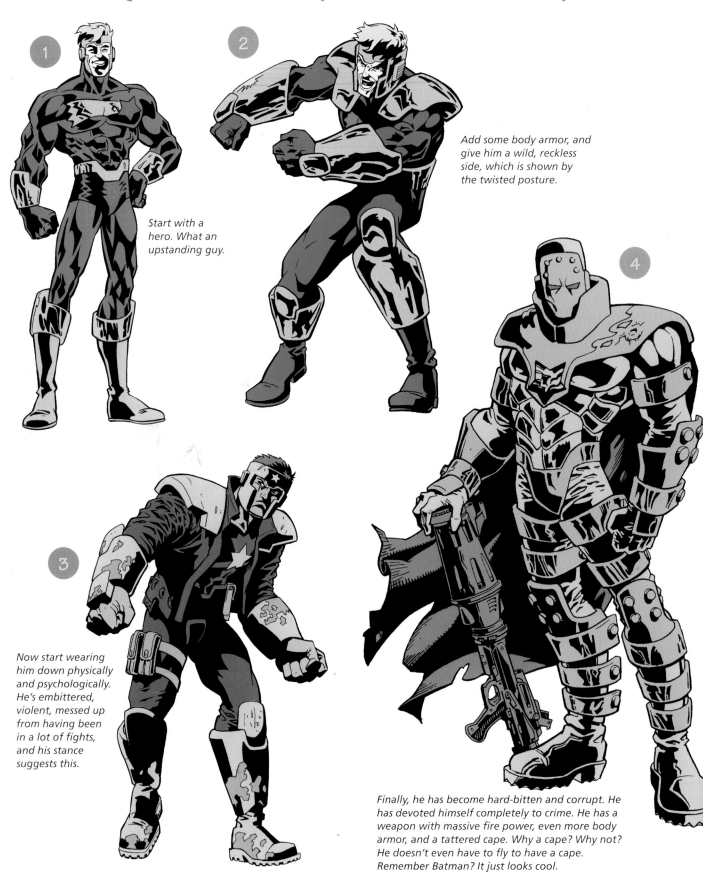

1 Start with a hero. What an upstanding guy.

2 Add some body armor, and give him a wild, reckless side, which is shown by the twisted posture.

3 Now start wearing him down physically and psychologically. He's embittered, violent, messed up from having been in a lot of fights, and his stance suggests this.

4 Finally, he has become hard-bitten and corrupt. He has devoted himself completely to crime. He has a weapon with massive fire power, even more body armor, and a tattered cape. Why a cape? Why not? He doesn't even have to fly to have a cape. Remember Batman? It just looks cool.

Turning a Good Gal into a Bad Gal

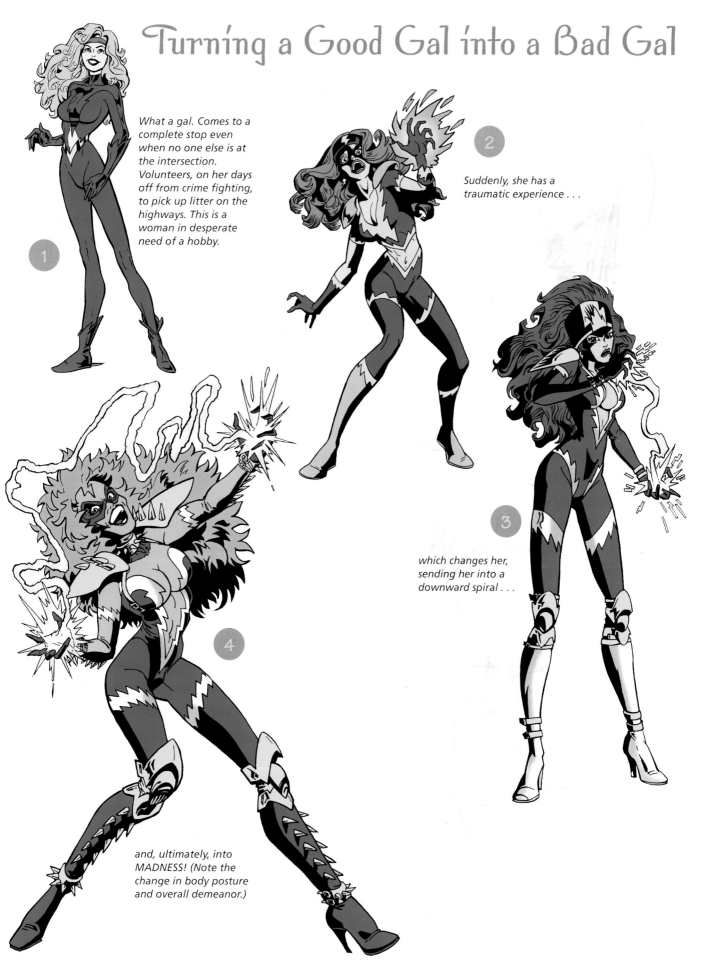

1 What a gal. Comes to a complete stop even when no one else is at the intersection. Volunteers, on her days off from crime fighting, to pick up litter on the highways. This is a woman in desperate need of a hobby.

2 Suddenly, she has a traumatic experience . . .

3 which changes her, sending her into a downward spiral . . .

4 and, ultimately, into MADNESS! (Note the change in body posture and overall demeanor.)

THE BODY IN ACTION

A stiff pose is a boring pose. Sometimes, an aspiring artist will show me his work. He'll have the proportions down and know the anatomy, but the drawings will have no flow, no thrust to the poses. It makes me want to tear them up into little, bitty pieces. But, I restrain myself because, number one, I don't want to hurt the guy's feelings, and number two, he's probably bigger than me.

WALKING

Three things happen when you walk. First, the weight-bearing leg pushes the hip higher on that side (her right hip is higher than her left hip here). Next, the body naturally compensates by dipping the shoulder on that same side (her right shoulder dips down). Finally, the head compensates for the drop in the shoulder by tilting in the opposite direction (her head tilts slightly to her left).

READY FOR ANYTHING

I like this type of pose because even though nothing is happening, the character looks so cool. The "ready" pose is one in which a character gets set to confront something. It's a good moment to capture before your character hauls off and decks someone.

STANDING

You can get creative even with the most mundane poses. Everything on the comic book page should have a level of excitement. It doesn't matter that people don't stand that way in real life. You're not drawing real life. You're drawing comic book characters. You want to draw real life? Paint a bowl of fruit. Talk about mundane!

A standing pose isn't usually interesting, so look for ways to make it interesting. By thrusting this character's hips forward, his chest and legs back, and planting his fists firmly on his sides, you can transform an ordinary pose into an eye-catching one.

LEAPING

When comic book characters jump, they don't jump the same way you might jump if you were jumping over, say, a puddle on the sidewalk. They thrust their whole bodies into it. They contort. They *yearn.* There's not a whole lot of middle ground. They commit fully or not at all.

Having One Main Thrust

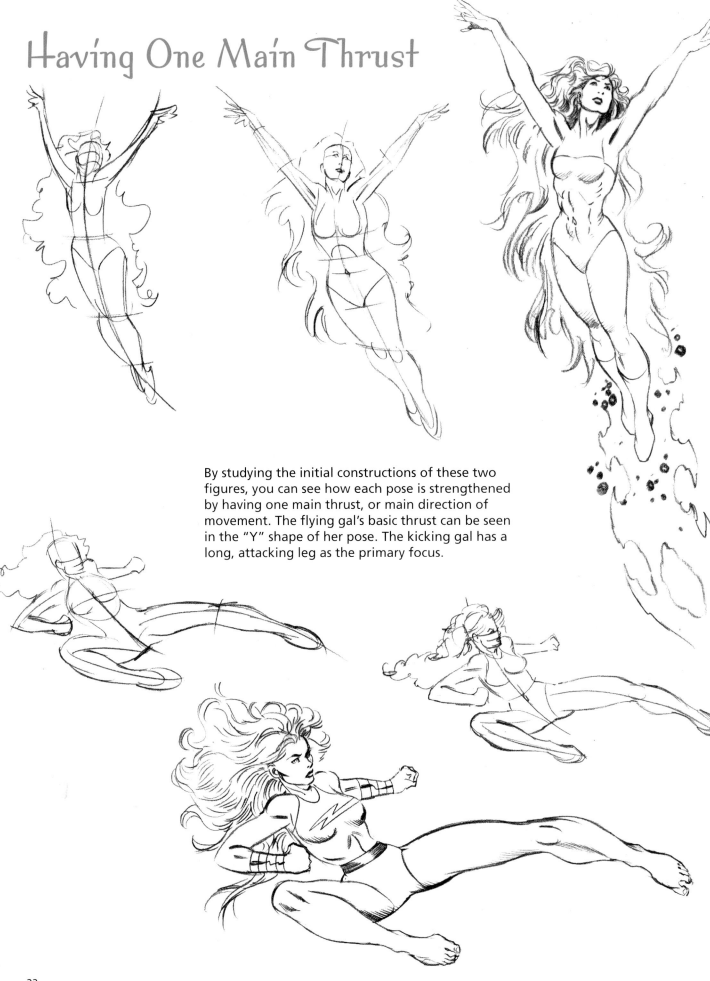

By studying the initial constructions of these two figures, you can see how each pose is strengthened by having one main thrust, or main direction of movement. The flying gal's basic thrust can be seen in the "Y" shape of her pose. The kicking gal has a long, attacking leg as the primary focus.

Using Posture to Reveal Personality

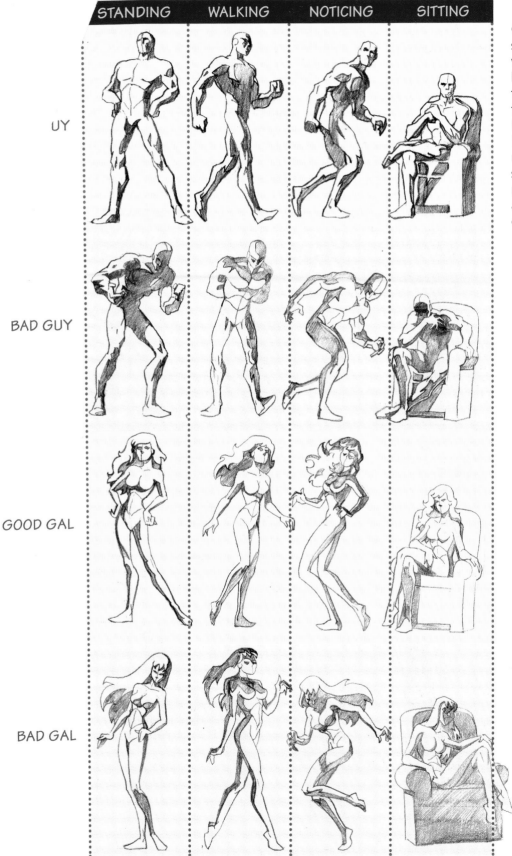

	STANDING	WALKING	NOTICING	SITTING
UY				
BAD GUY				
GOOD GAL				
BAD GAL				

Good guys are pretty straightforward. They walk with their chest out, head held high, nothing to hide and nothing to fear. Not so with bad guys. Bad guys have lots of inner demons and secret motives at play, and this should show in their posture. Think of posture as the physical equivalent of a lie detector test.

Character Acting

The term *character acting* is used by animators and comic book artists. It means that you're not just making drawings, you're really creating performances through your characters. Your characters are just like actors, except that they don't talk about themselves all the time. But, other than that, they must be able to communicate attitudes the same way an actor does.

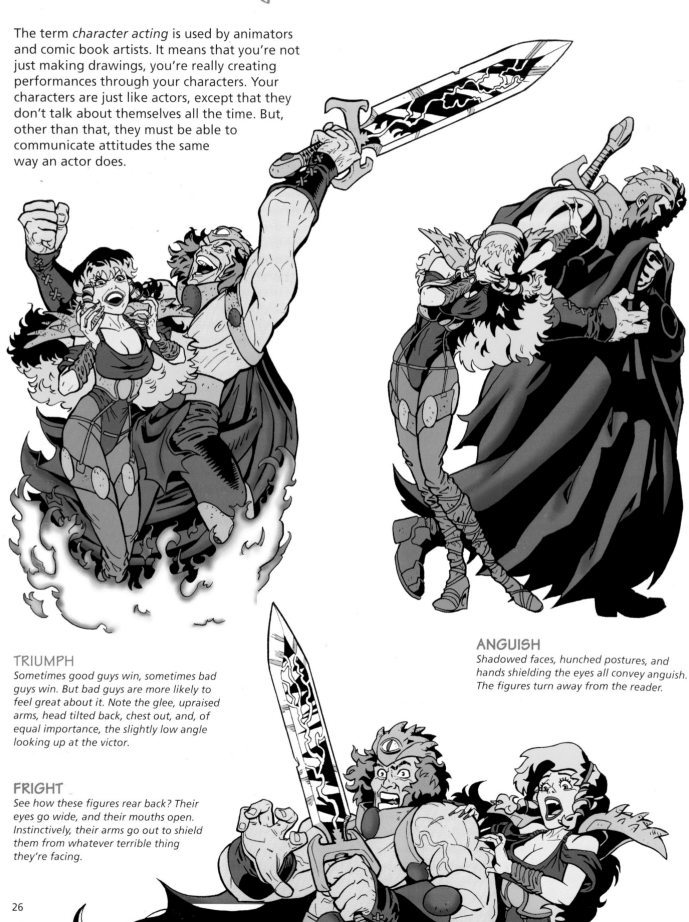

TRIUMPH
Sometimes good guys win, sometimes bad guys win. But bad guys are more likely to feel great about it. Note the glee, upraised arms, head tilted back, chest out, and, of equal importance, the slightly low angle looking up at the victor.

FRIGHT
See how these figures rear back? Their eyes go wide, and their mouths open. Instinctively, their arms go out to shield them from whatever terrible thing they're facing.

ANGUISH
Shadowed faces, hunched postures, and hands shielding the eyes all convey anguish. The figures turn away from the reader.

RAGE
Here, their whole bodies tense up. They lean forward, aggressively. Their eyes bulge, and lots of teeth show.

BROODING
When bad guys and gals brood, they're hatching a plan. Rubbing a finger across the chin connotes thinking. Deep shadows show dark thoughts. Characters look down for dark thoughts and up for hopeful thoughts.

SKULKING
When characters skulk, they act very cautiously. Since the most important thing is to not get caught, they move slowly and tentatively, peering around corners before they make that move forward.

Street Fighting

Sometimes bad guys resort to fighting—yes, fighting. I know, it's a shocker. Maybe someday we'll live in a world where all action heroes and their evil enemies will be friends, but until then, we can still enjoy watching them pulverize the heck out of one another!

THE KNOCKOUT PUNCH

In life, there are many types of punches: the jab; the hook, the uppercut, and the right cross. In comic books, there is only one type of punch: the *knockout* punch. Your character must go for the knockout every single time he (or she) throws a punch. The actual punch thrown will be a right cross, also known as the "straight right."

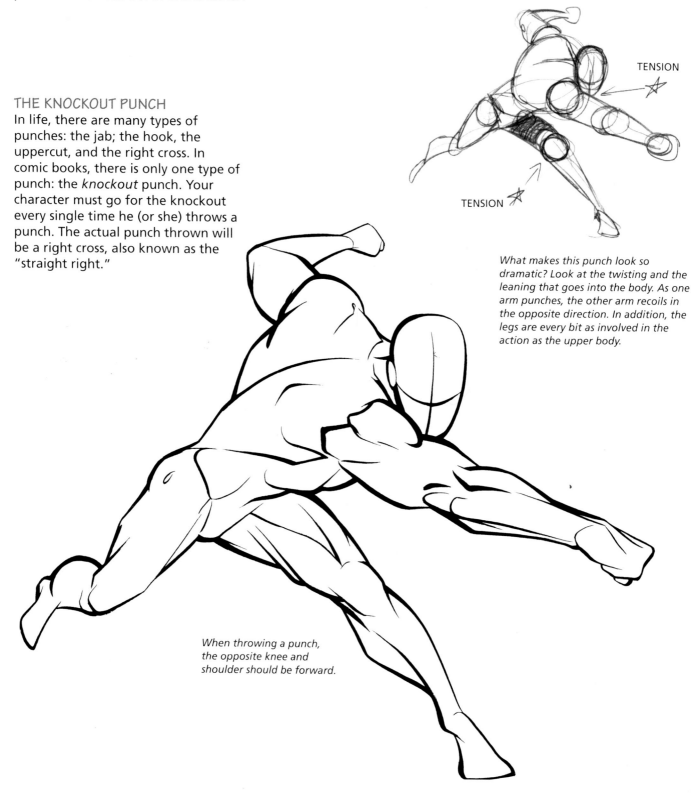

TENSION

TENSION

What makes this punch look so dramatic? Look at the twisting and the leaning that goes into the body. As one arm punches, the other arm recoils in the opposite direction. In addition, the legs are every bit as involved in the action as the upper body.

When throwing a punch, the opposite knee and shoulder should be forward.

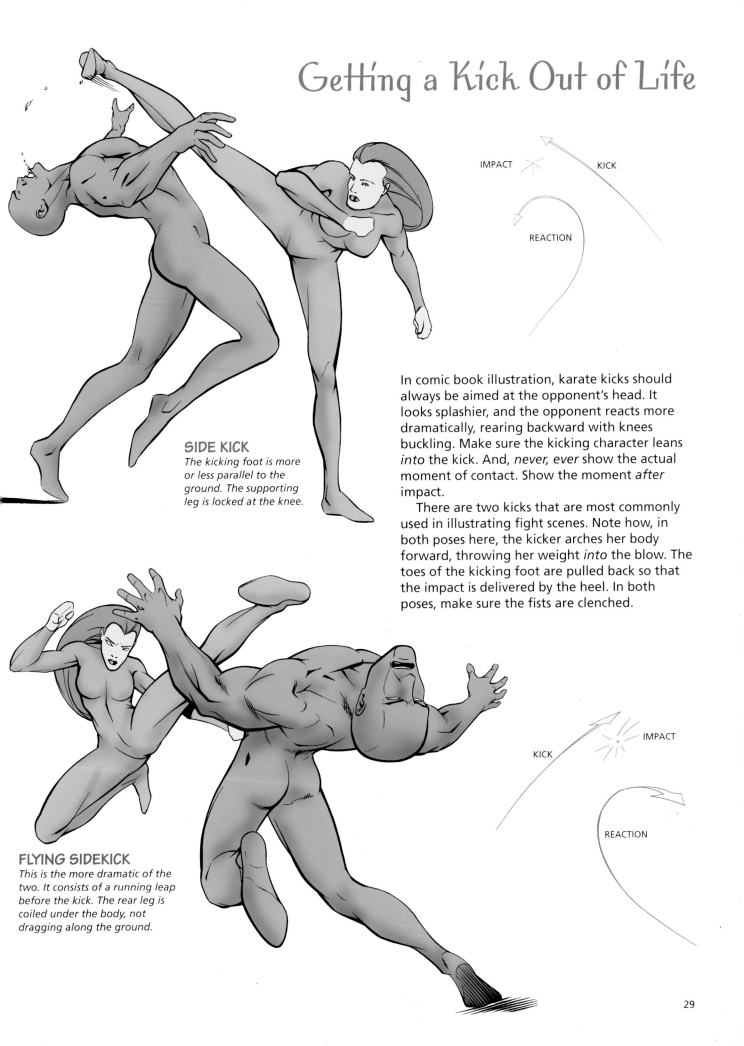

Getting a Kick Out of Life

IMPACT

KICK

REACTION

SIDE KICK
The kicking foot is more or less parallel to the ground. The supporting leg is locked at the knee.

In comic book illustration, karate kicks should always be aimed at the opponent's head. It looks splashier, and the opponent reacts more dramatically, rearing backward with knees buckling. Make sure the kicking character leans *into* the kick. And, *never, ever* show the actual moment of contact. Show the moment *after* impact.

There are two kicks that are most commonly used in illustrating fight scenes. Note how, in both poses here, the kicker arches her body forward, throwing her weight *into* the blow. The toes of the kicking foot are pulled back so that the impact is delivered by the heel. In both poses, make sure the fists are clenched.

FLYING SIDEKICK
This is the more dramatic of the two. It consists of a running leap before the kick. The rear leg is coiled under the body, not dragging along the ground.

KICK

IMPACT

REACTION

Fighting Dirty

Bad guys and gals are so dangerous because there's nothing they won't do. When backed into a corner, they don't play fair, and this gives them an edge over the good guy. Bad guys and gals will make a weapon out of anything. In addition, they are typically stronger than their hero counterparts, which serves to heighten the drama and get you rooting for the good guy (who you know is going to win anyway).

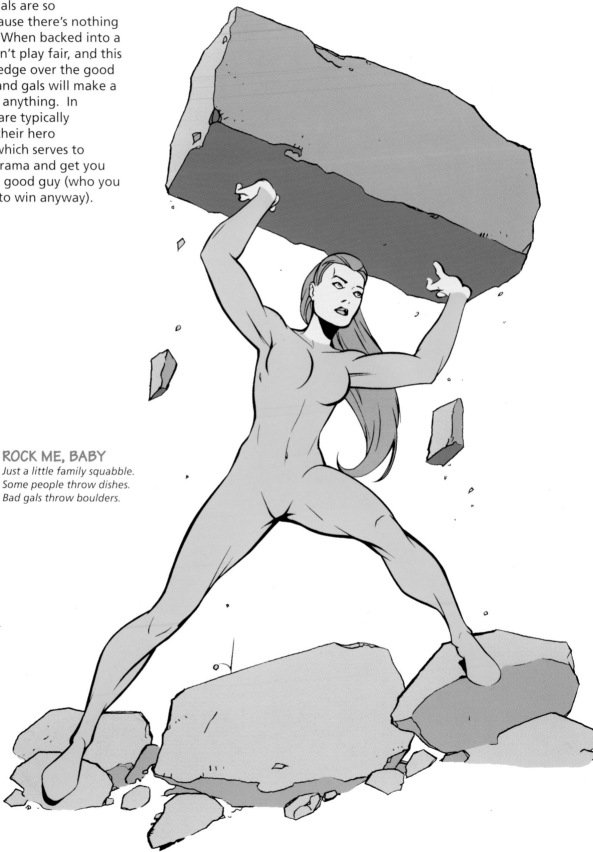

ROCK ME, BABY
Just a little family squabble.
Some people throw dishes.
Bad gals throw boulders.

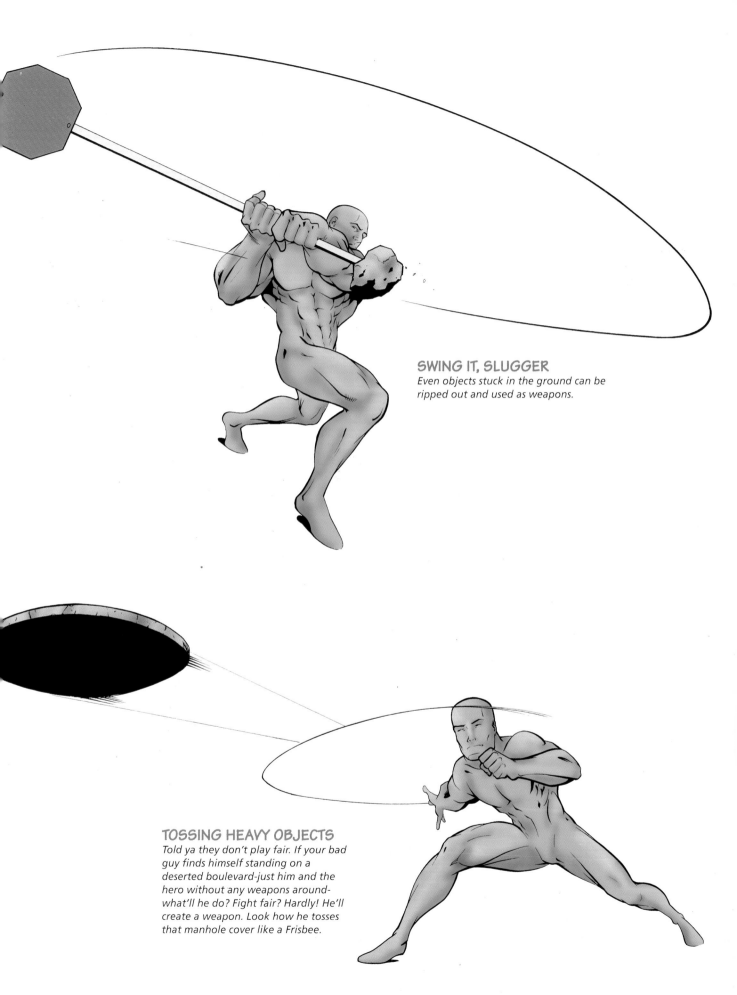

SWING IT, SLUGGER
Even objects stuck in the ground can be ripped out and used as weapons.

TOSSING HEAVY OBJECTS
Told ya they don't play fair. If your bad guy finds himself standing on a deserted boulevard-just him and the hero without any weapons around-what'll he do? Fight fair? Hardly! He'll create a weapon. Look how he tosses that manhole cover like a Frisbee.

USING LIGHT AND SHADOW TO CREATE CHARACTER

When you think of someone lurking in the shadows, it's not usually the Lone Ranger you're thinking about. It's a bad guy. By shifting the position of the light source, thereby casting shadows precisely where you want them, you can give even the most benign character an evil appearance. So imagine what shadows can do for truly evil-looking characters!

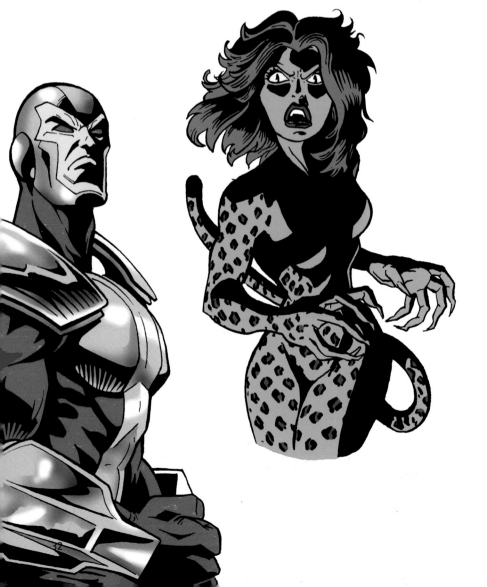

NORMAL LIGHTING
This light is unfocused; perhaps it's from an overhead light in a well-lit room. The light bounces off of the walls, illuminating everything and casting only a small shadow under the chin.

SIDE LIGHTING
Shining a light on one side of the face, while the other side remains bathed in shadow, creates a dramatic image.

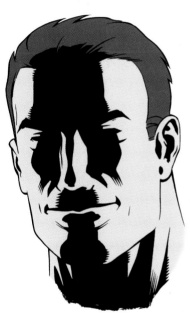

MIDDLE SHADOW
Here's what happens when you take the same fella and hit him with two bursts of heavy, concentrated light in a dark room. The light hits him from both the left and right but leaves his face in shadow. Even though this is the same face as in the previous example, it now has an unmistakably evil feeling.

LIGHTING FROM BELOW
Also referred to as under lighting, shining a light from below a character always produces an ominous, otherworldly feeling. Anything that protrudes beyond the flat plane of the face causes a shadow to be cast upward on the face. The protruding elements are the chin, lower lip, upper lip, nose, cheekbones, and eyebrows.

OVERHEAD LIGHTING
Anything that protrudes above or caves below the flat plane of the face will cause a shadow from an overhead light. Since the eyes sink back (or cave) in the skull, the forehead casts a shadow on the eyes. The nose protrudes, casting a shadow on the upper lip, and the chin protrudes, casting a shadow under the jaw.

The Effect of Two Light Sources

Even if there is only one light source, for example, an overhead lamp, that light is probably bouncing off of the walls (and objects) in the room and dimly illuminating other areas of the character. Even the parts of the model that are bathed in shadow will probably still have portions that are hit with a *secondary*, though dimmer, light source, such as light from a hallway.

AMBIENT LIGHT— NORMAL LIGHT CONDITIONS
The figure, though dramatically drawn, looks flat without some shadow to give it depth.

STRONG LIGHT SOURCE

WEAK (SECONDARY) LIGHT SOURCE

DIM LIGHT SOURCE

DIM LIGHT SOURCE

ONE STRONG LIGHT SOURCE/ ONE WEAK LIGHT SOURCE

TWO WEAK LIGHT SOURCES

With two weak sources of light, the figure is almost entirely in shadow. This is also referred to as "edge" lighting and is useful to depict a scene in which there is no light at all, such as a solitary-confinement prison cell. Even when there is supposed to be no light in a scene, you can't very well draw an all-black panel. In these instances, edge lighting will allow you to show some features, while maintaining the feeling of total darkness. In addition, it works very well to show an extremely menacing character, such as this one.

Get Creative with Shadows

In comic book cartooning, it's up to the penciler (the person who draws the pencil drawings) to indicate the shaded areas so that the inker (the person who does the inking over the pencil drawings) will know which areas to blacken out. Creating areas of shadow is not an exact science. Sure, there are specific light sources and all that stuff, but the bottom line is that you want it to look cool.

Take the two bad guys here, for example. Their dark and light areas have been reversed. The figure on the left has shadows on his shoulders, chest, abdominal muscles, and upper legs, while the figure on the right has shadows not on those areas, but instead, on his forearms, ribs, and lower legs. Which one is correct? Unless you reveal the exact location of a strong light source in the comic book panel itself, they both are. It all depends on which you think looks the best.

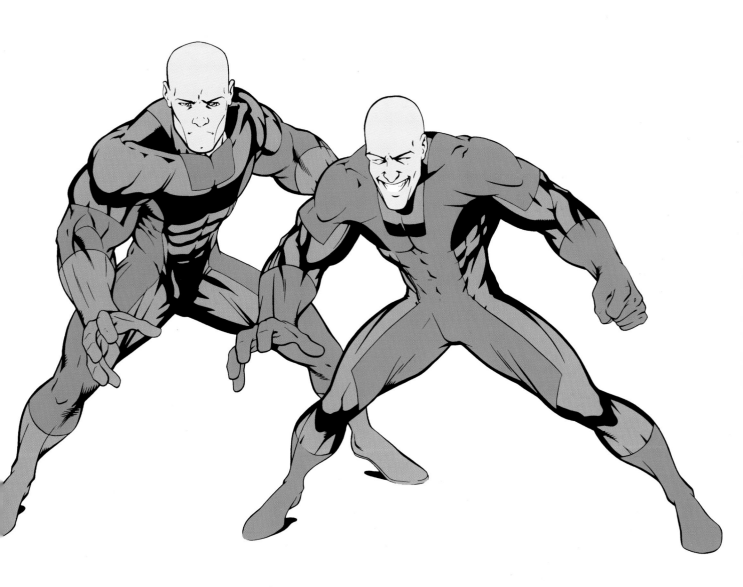

THE BAD ONES

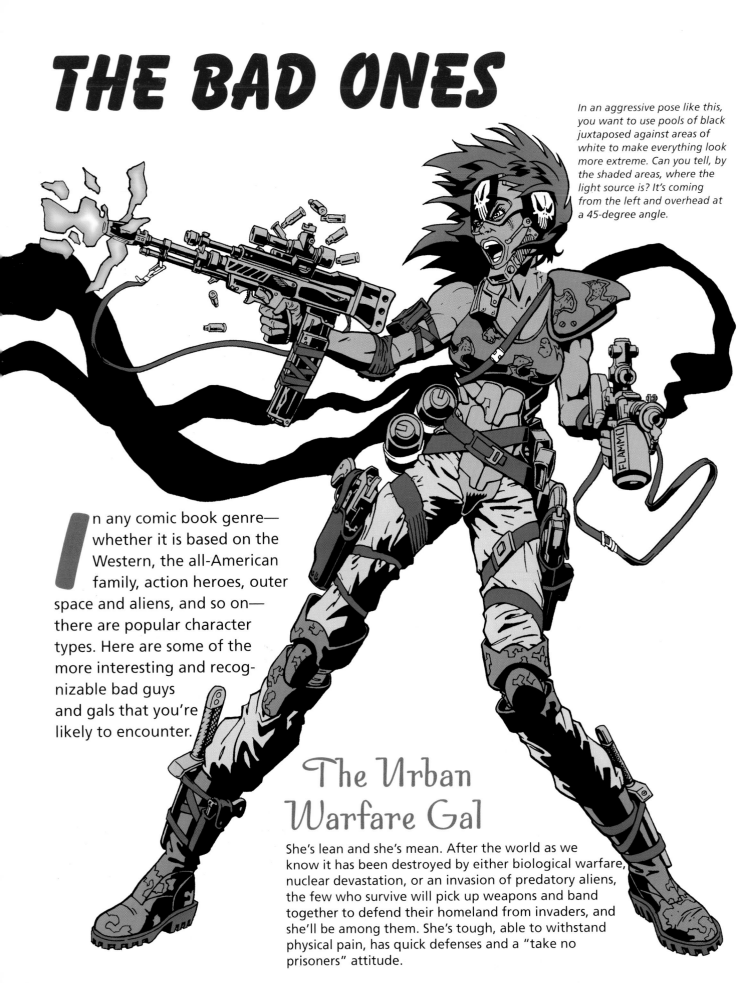

In any comic book genre—whether it is based on the Western, the all-American family, action heroes, outer space and aliens, and so on—there are popular character types. Here are some of the more interesting and recognizable bad guys and gals that you're likely to encounter.

The Urban Warfare Gal

She's lean and she's mean. After the world as we know it has been destroyed by either biological warfare, nuclear devastation, or an invasion of predatory aliens, the few who survive will pick up weapons and band together to defend their homeland from invaders, and she'll be among them. She's tough, able to withstand physical pain, has quick defenses and a "take no prisoners" attitude.

The Oversized Brute

Rough out the basic pose. Be sure to get the tilt of the shoulders, which slope sharply downward toward the hammerlike fist. That front knee should look like it's coming toward us. To accomplish this, use the foreshortening technique of overlapping. Rough out the knee as a small circle and the thigh as a bigger circle that surrounds it. On the rear leg, notice how the thigh overlaps the calf, making the thigh appear closer to us. Also notice that the size of the fist is greatly exaggerated; due to perspective, things that are closer to us must appear larger.

Now tighten up your sketch, adding the articulations of the various joints and muscle groups. This is one guy who doesn't respond favorably to teasing.

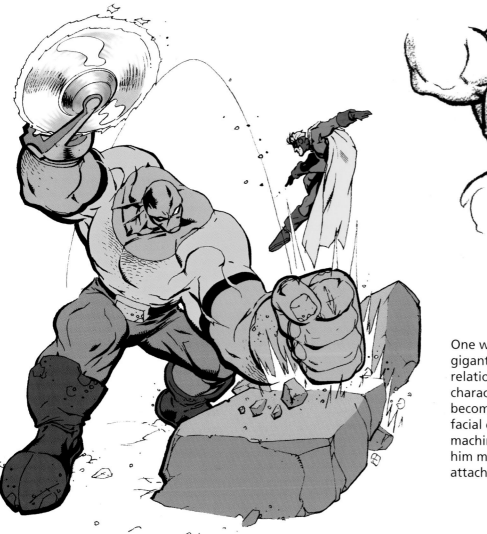

DETAIL OF MUSCLE GROUPS

One way to make a character look gigantic is to make the body huge in relation to the head. It also makes the character look evil, because the focus becomes the powerful body, not the facial expressions. This guy is like a machine, bent on destruction. To make him more machinelike, you can even attach weapons to parts of his body.

A Girl and Her Komodo Dragon

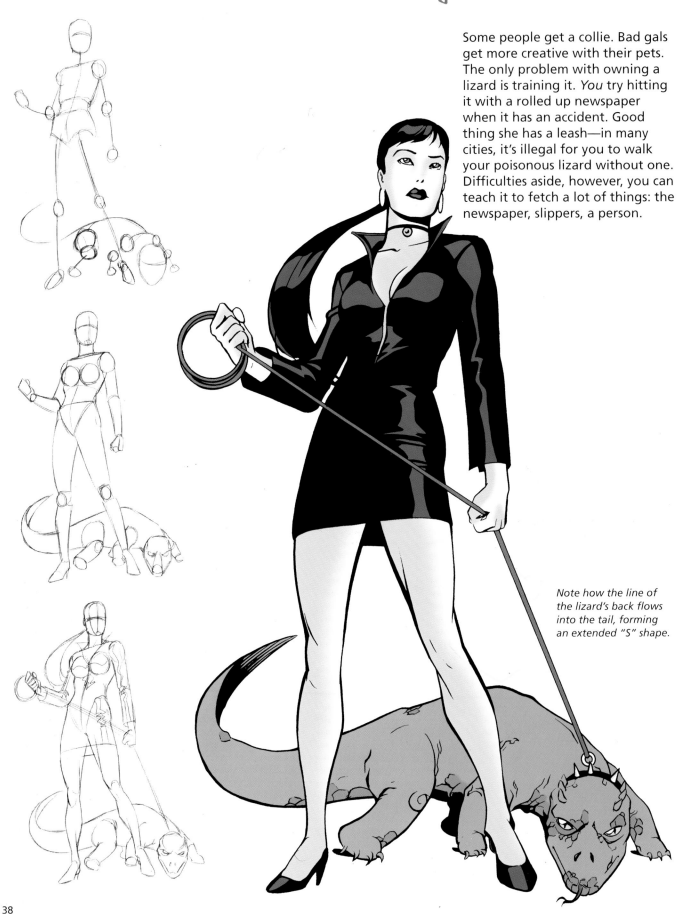

Some people get a collie. Bad gals get more creative with their pets. The only problem with owning a lizard is training it. *You* try hitting it with a rolled up newspaper when it has an accident. Good thing she has a leash—in many cities, it's illegal for you to walk your poisonous lizard without one. Difficulties aside, however, you can teach it to fetch a lot of things: the newspaper, slippers, a person.

Note how the line of the lizard's back flows into the tail, forming an extended "S" shape.

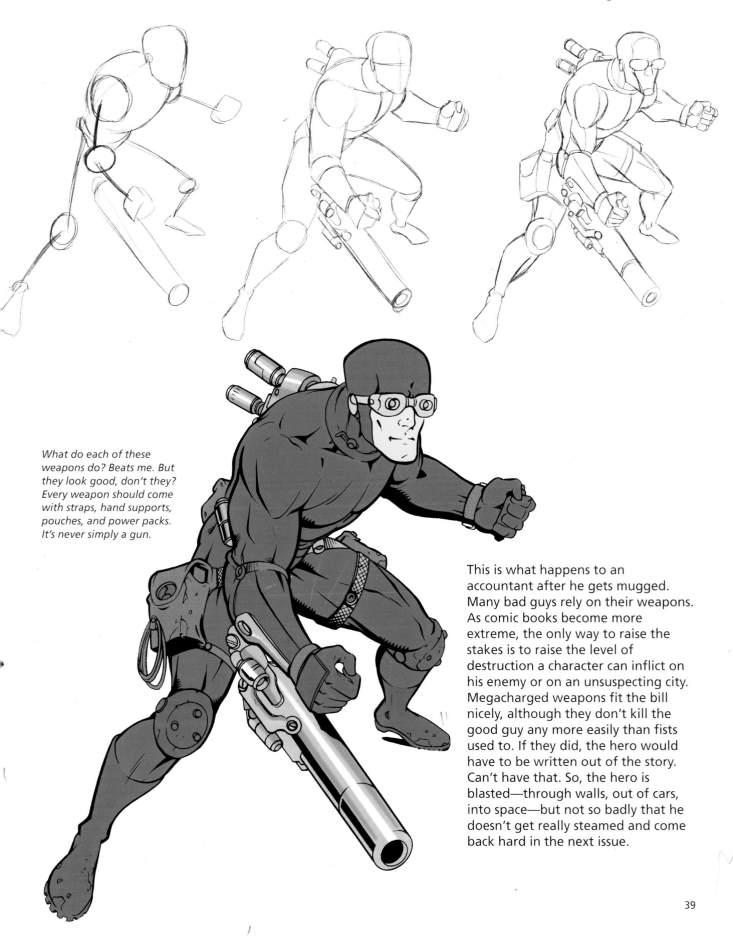

Armed and Dangerous

What do each of these weapons do? Beats me. But they look good, don't they? Every weapon should come with straps, hand supports, pouches, and power packs. It's never simply a gun.

This is what happens to an accountant after he gets mugged. Many bad guys rely on their weapons. As comic books become more extreme, the only way to raise the stakes is to raise the level of destruction a character can inflict on his enemy or on an unsuspecting city. Megacharged weapons fit the bill nicely, although they don't kill the good guy any more easily than fists used to. If they did, the hero would have to be written out of the story. Can't have that. So, the hero is blasted—through walls, out of cars, into space—but not so badly that he doesn't get really steamed and come back hard in the next issue.

Queen of the Animals

In advertising, placing good looking women on horseback or in a rugged vehicle creates a certain appeal. It's that same principle at work when you have a great looking woman riding on the back of a ferocious animal. Since she's sort of a wild animal herself, she doesn't wear a tight body costume, but *pieces* of clothing. The costume is a blend of themes, including African, Egyptian, and aerobics instructor.

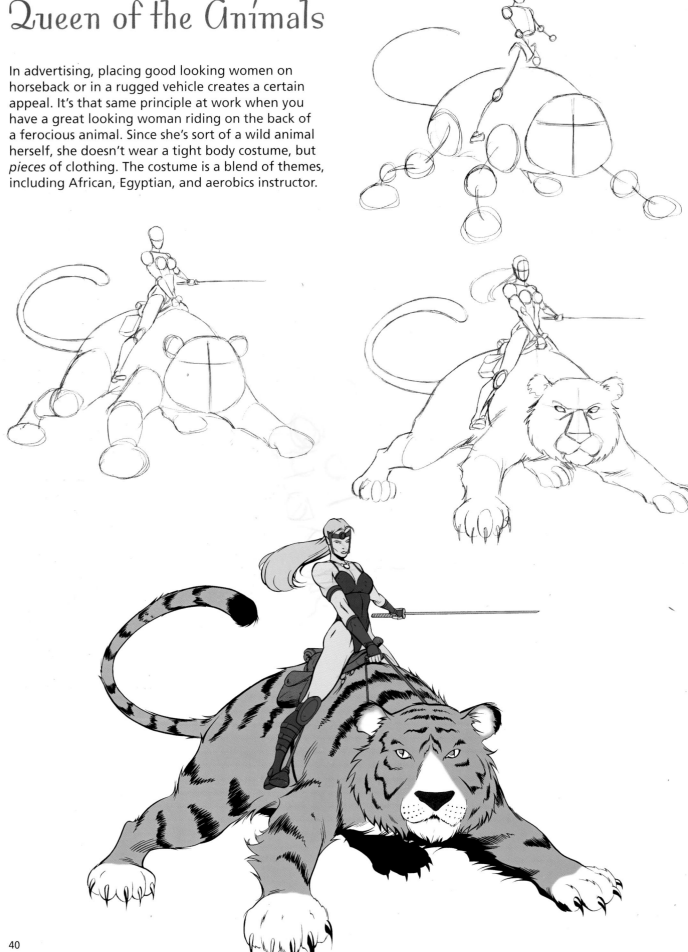

Hollywood Heavies

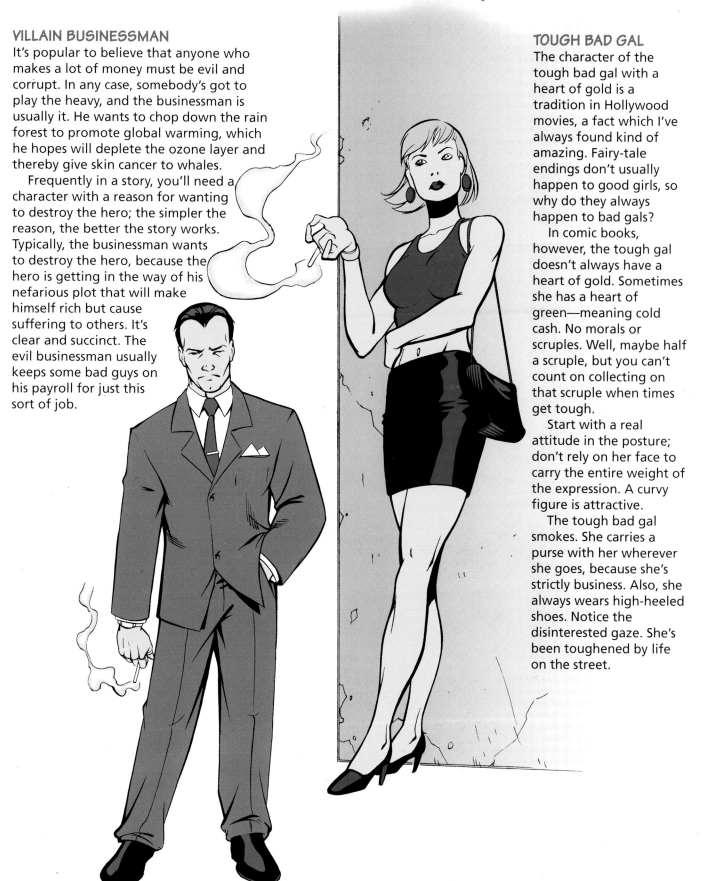

VILLAIN BUSINESSMAN

It's popular to believe that anyone who makes a lot of money must be evil and corrupt. In any case, somebody's got to play the heavy, and the businessman is usually it. He wants to chop down the rain forest to promote global warming, which he hopes will deplete the ozone layer and thereby give skin cancer to whales.

Frequently in a story, you'll need a character with a reason for wanting to destroy the hero; the simpler the reason, the better the story works. Typically, the businessman wants to destroy the hero, because the hero is getting in the way of his nefarious plot that will make himself rich but cause suffering to others. It's clear and succinct. The evil businessman usually keeps some bad guys on his payroll for just this sort of job.

TOUGH BAD GAL

The character of the tough bad gal with a heart of gold is a tradition in Hollywood movies, a fact which I've always found kind of amazing. Fairy-tale endings don't usually happen to good girls, so why do they always happen to bad gals?

In comic books, however, the tough gal doesn't always have a heart of gold. Sometimes she has a heart of green—meaning cold cash. No morals or scruples. Well, maybe half a scruple, but you can't count on collecting on that scruple when times get tough.

Start with a real attitude in the posture; don't rely on her face to carry the entire weight of the expression. A curvy figure is attractive.

The tough bad gal smokes. She carries a purse with her wherever she goes, because she's strictly business. Also, she always wears high-heeled shoes. Notice the disinterested gaze. She's been toughened by life on the street.

Never Skips Dessert

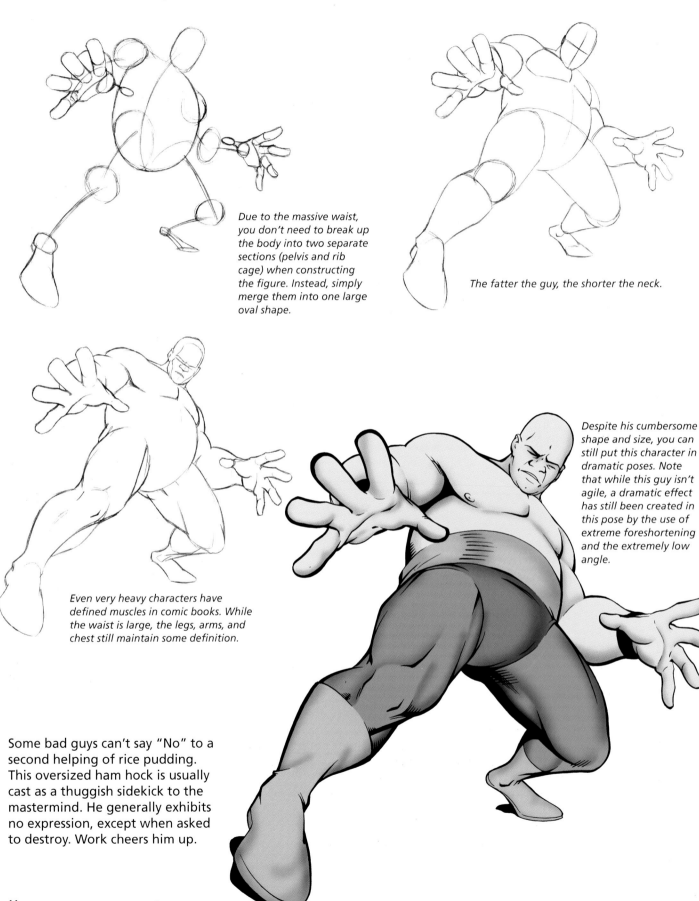

Due to the massive waist, you don't need to break up the body into two separate sections (pelvis and rib cage) when constructing the figure. Instead, simply merge them into one large oval shape.

The fatter the guy, the shorter the neck.

Even very heavy characters have defined muscles in comic books. While the waist is large, the legs, arms, and chest still maintain some definition.

Despite his cumbersome shape and size, you can still put this character in dramatic poses. Note that while this guy isn't agile, a dramatic effect has still been created in this pose by the use of extreme foreshortening and the extremely low angle.

Some bad guys can't say "No" to a second helping of rice pudding. This oversized ham hock is usually cast as a thuggish sidekick to the mastermind. He generally exhibits no expression, except when asked to destroy. Work cheers him up.

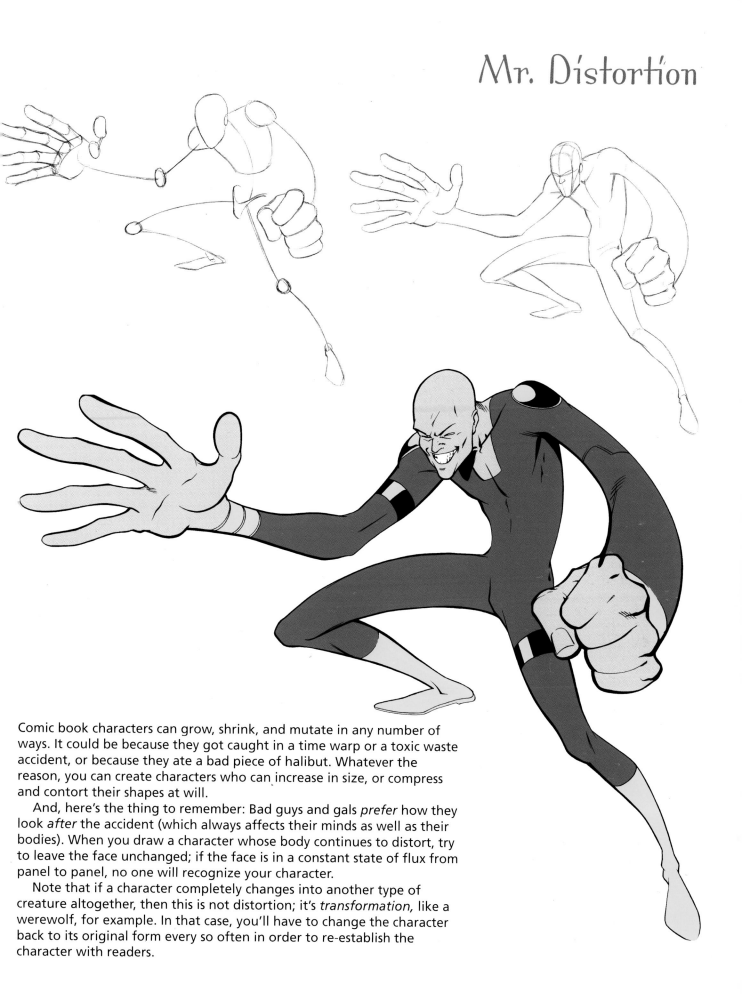

Mr. Distortion

Comic book characters can grow, shrink, and mutate in any number of ways. It could be because they got caught in a time warp or a toxic waste accident, or because they ate a bad piece of halibut. Whatever the reason, you can create characters who can increase in size, or compress and contort their shapes at will.

And, here's the thing to remember: Bad guys and gals *prefer* how they look *after* the accident (which always affects their minds as well as their bodies). When you draw a character whose body continues to distort, try to leave the face unchanged; if the face is in a constant state of flux from panel to panel, no one will recognize your character.

Note that if a character completely changes into another type of creature altogether, then this is not distortion; it's *transformation*, like a werewolf, for example. In that case, you'll have to change the character back to its original form every so often in order to re-establish the character with readers.

Boo!—Spooky Babes

There's nothing so unnerving as a spooky bad gal, except, maybe that blind date your Aunt Doris set you up on. Spooky babes are seductive yet frightening. Beautiful yet evil. Enchanting yet creepy. Tall yet short. Thin yet fat. Cold yet hot. Stop me before I compare again! These are the gals who get their dark powers from the netherworld, who conjure up their evil from spells and trinkets, ambulates and potions.

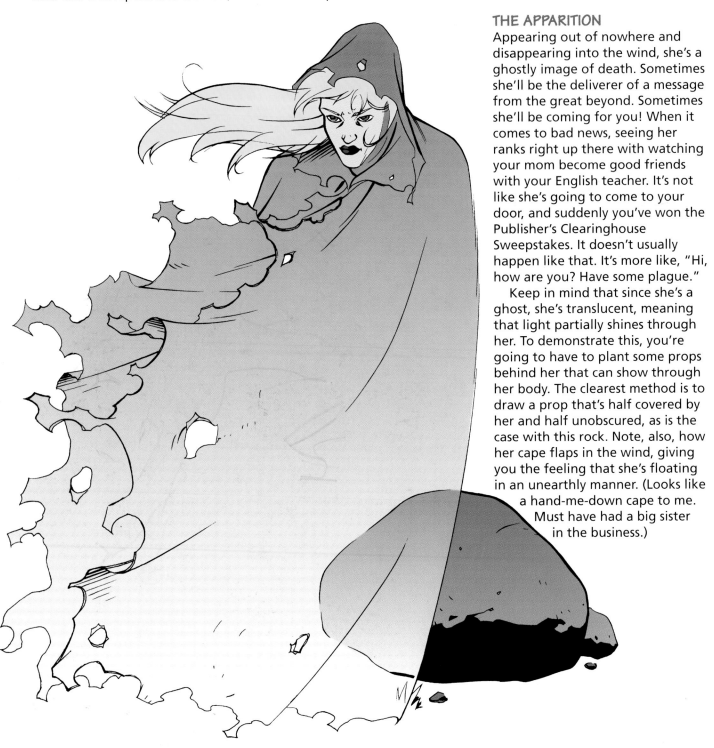

THE APPARITION

Appearing out of nowhere and disappearing into the wind, she's a ghostly image of death. Sometimes she'll be the deliverer of a message from the great beyond. Sometimes she'll be coming for you! When it comes to bad news, seeing her ranks right up there with watching your mom become good friends with your English teacher. It's not like she's going to come to your door, and suddenly you've won the Publisher's Clearinghouse Sweepstakes. It doesn't usually happen like that. It's more like, "Hi, how are you? Have some plague."

Keep in mind that since she's a ghost, she's translucent, meaning that light partially shines through her. To demonstrate this, you're going to have to plant some props behind her that can show through her body. The clearest method is to draw a prop that's half covered by her and half unobscured, as is the case with this rock. Note, also, how her cape flaps in the wind, giving you the feeling that she's floating in an unearthly manner. (Looks like a hand-me-down cape to me. Must have had a big sister in the business.)

Disgusting, Repulsive, & Vile

In the high school yearbook, this guy was voted least likely to bathe. Some characters are really repulsive. Anything you can add that will gross you out, add. It could mean adding ill-fitting clothing, yellowed teeth, a blemished face, excessive weight, drool, flies, you name it.

This guy here has what is almost a shrunken head, a chopped off nose, leaves growing from his arms, flayed skin, and a few flies buzzing about (the kind that feed off corpses).

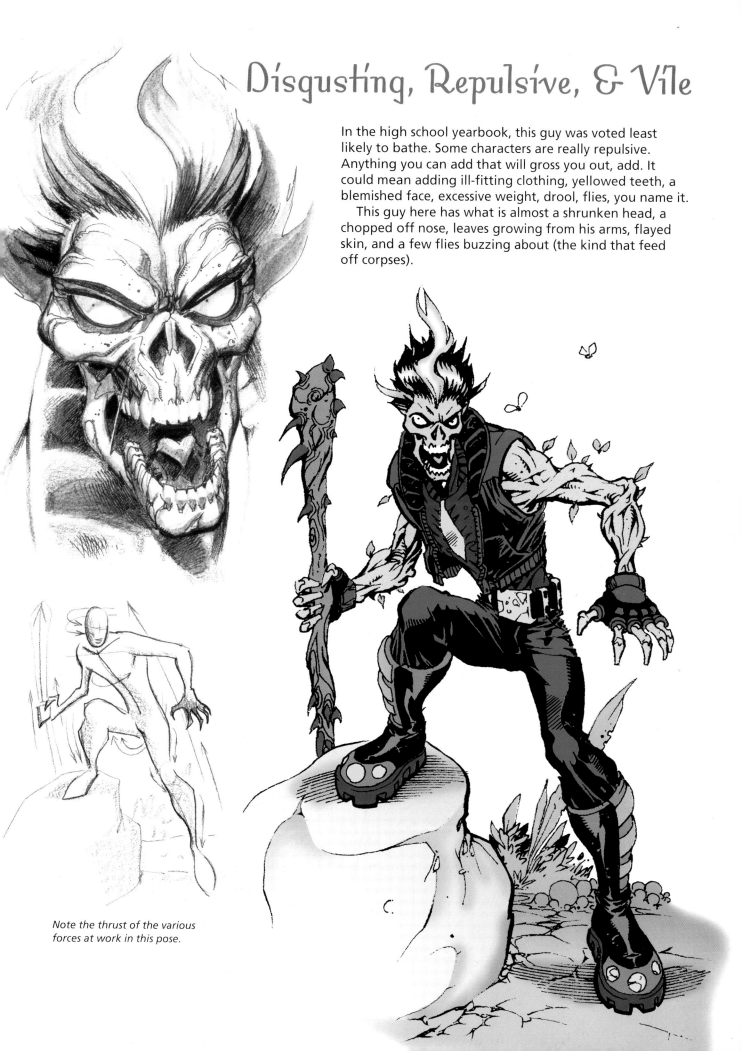

Note the thrust of the various forces at work in this pose.

Demon Woman

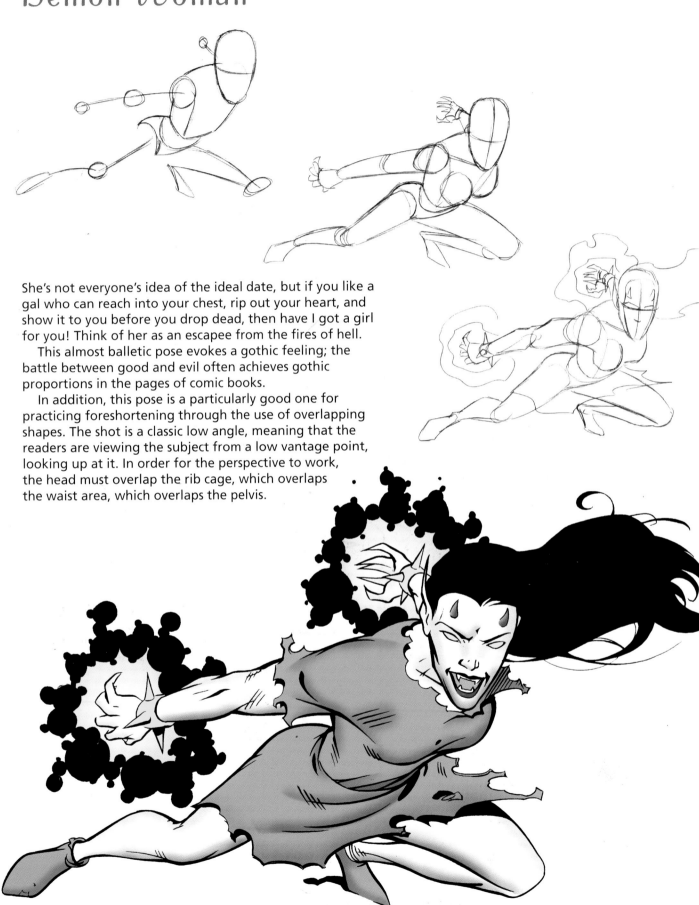

She's not everyone's idea of the ideal date, but if you like a gal who can reach into your chest, rip out your heart, and show it to you before you drop dead, then have I got a girl for you! Think of her as an escapee from the fires of hell.

This almost balletic pose evokes a gothic feeling; the battle between good and evil often achieves gothic proportions in the pages of comic books.

In addition, this pose is a particularly good one for practicing foreshortening through the use of overlapping shapes. The shot is a classic low angle, meaning that the readers are viewing the subject from a low vantage point, looking up at it. In order for the perspective to work, the head must overlap the rib cage, which overlaps the waist area, which overlaps the pelvis.

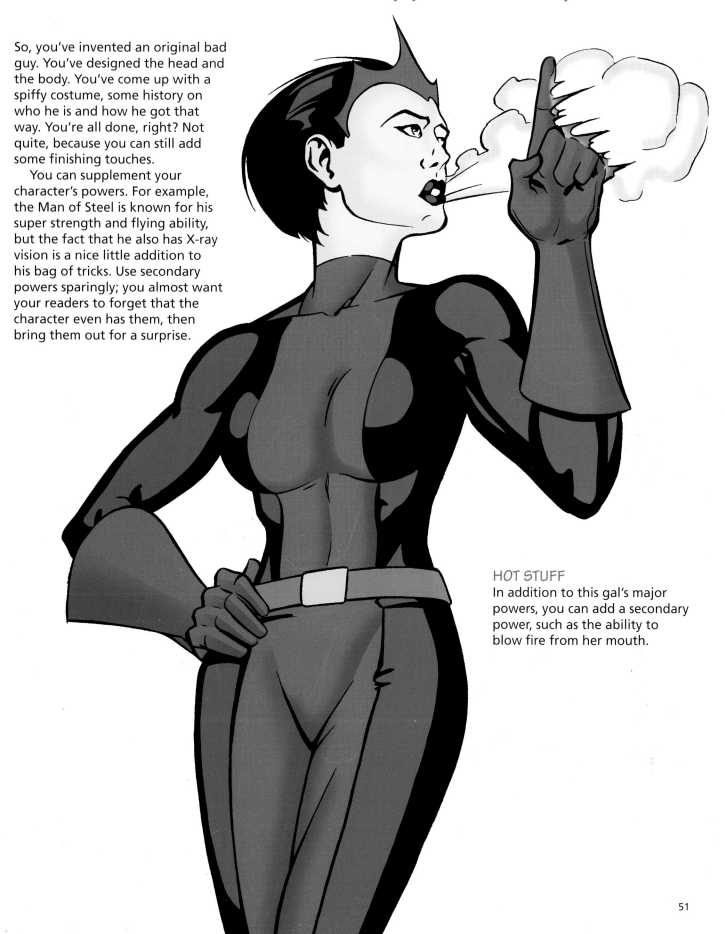

So, you've invented an original bad guy. You've designed the head and the body. You've come up with a spiffy costume, some history on who he is and how he got that way. You're all done, right? Not quite, because you can still add some finishing touches.

You can supplement your character's powers. For example, the Man of Steel is known for his super strength and flying ability, but the fact that he also has X-ray vision is a nice little addition to his bag of tricks. Use secondary powers sparingly; you almost want your readers to forget that the character even has them, then bring them out for a surprise.

HOT STUFF
In addition to this gal's major powers, you can add a secondary power, such as the ability to blow fire from her mouth.

Non-Human Bad Guys

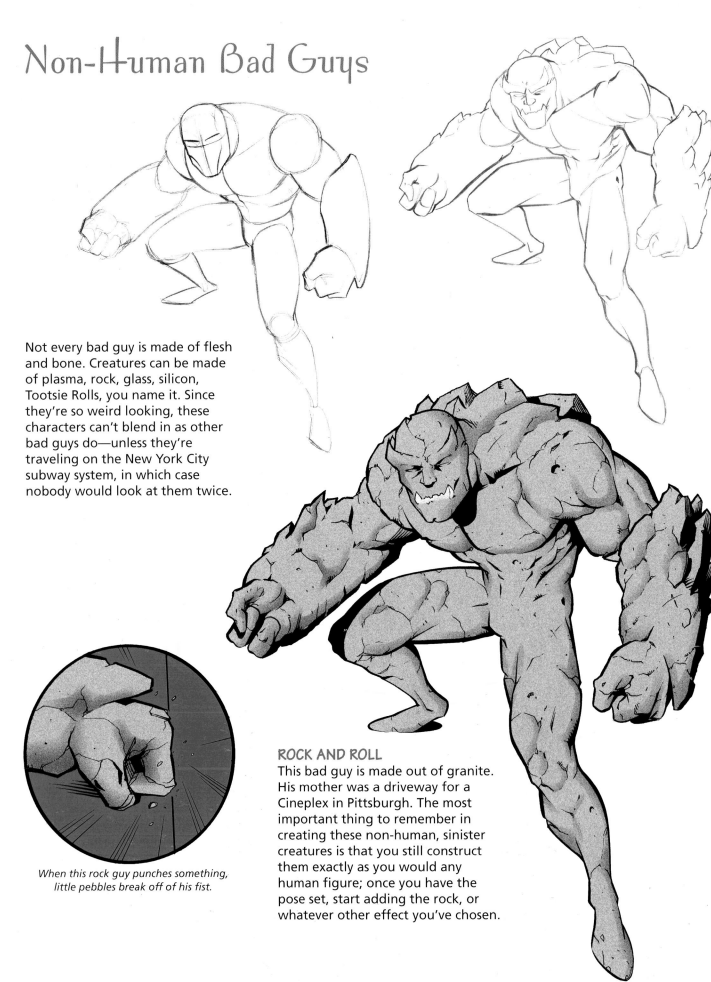

Not every bad guy is made of flesh and bone. Creatures can be made of plasma, rock, glass, silicon, Tootsie Rolls, you name it. Since they're so weird looking, these characters can't blend in as other bad guys do—unless they're traveling on the New York City subway system, in which case nobody would look at them twice.

When this rock guy punches something, little pebbles break off of his fist.

ROCK AND ROLL

This bad guy is made out of granite. His mother was a driveway for a Cineplex in Pittsburgh. The most important thing to remember in creating these non-human, sinister creatures is that you still construct them exactly as you would any human figure; once you have the pose set, start adding the rock, or whatever other effect you've chosen.

Guys with Claws

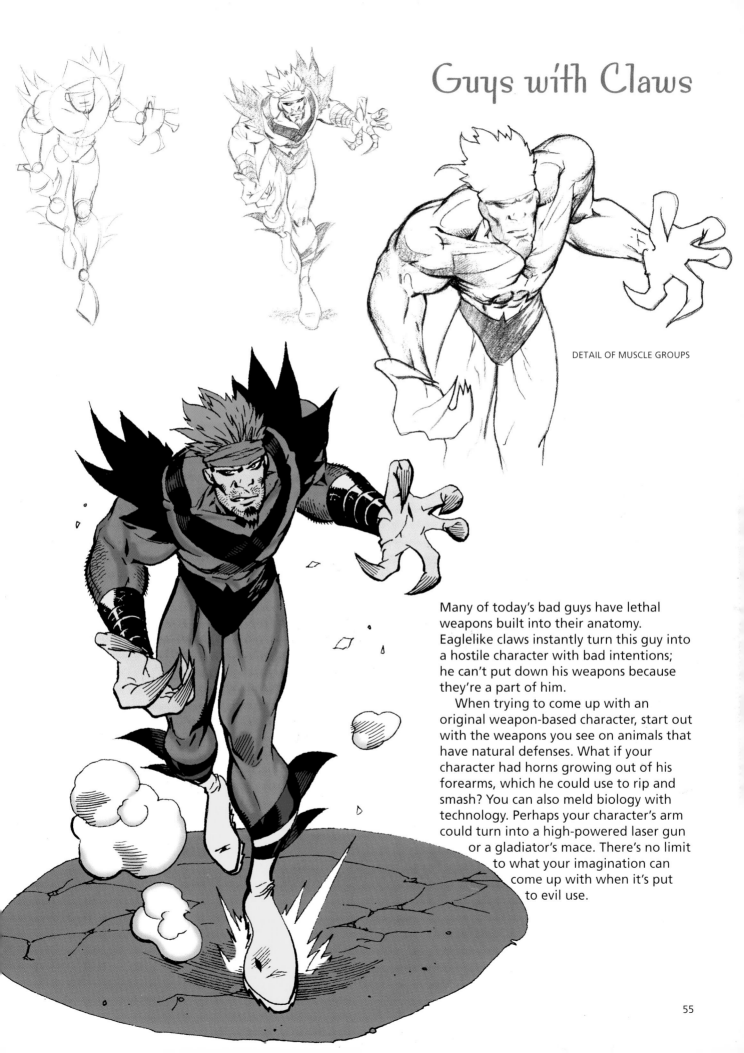

DETAIL OF MUSCLE GROUPS

Many of today's bad guys have lethal weapons built into their anatomy. Eaglelike claws instantly turn this guy into a hostile character with bad intentions; he can't put down his weapons because they're a part of him.

When trying to come up with an original weapon-based character, start out with the weapons you see on animals that have natural defenses. What if your character had horns growing out of his forearms, which he could use to rip and smash? You can also meld biology with technology. Perhaps your character's arm could turn into a high-powered laser gun or a gladiator's mace. There's no limit to what your imagination can come up with when it's put to evil use.

COMPOSITION: HOW TO DESIGN A COMIC BOOK PANEL

Even if you've put in a lot of work into drawing your bad guys and gals, you will blow the whole effect by lumping them together randomly in a comic book panel. This can make the panel hard to read, and as a result, the panel will lose its impact. And impact is what comics are all about.

There are two main elements at work in creating visual impact in a panel. The first is *foreground/background dynamics.* When you place one person or object in the foreground and another person or object in the background, the look is far more dramatic than when you have two people standing in the same spot yapping at each other. The second factor in achieving an interesting design is *spacing and rhythm.* Space the objects in the panel apart from one another but at irregular intervals.

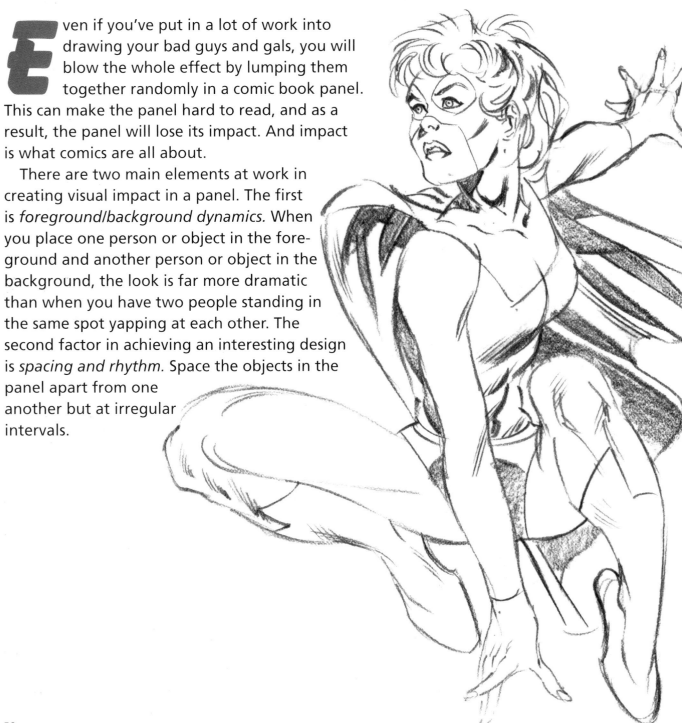

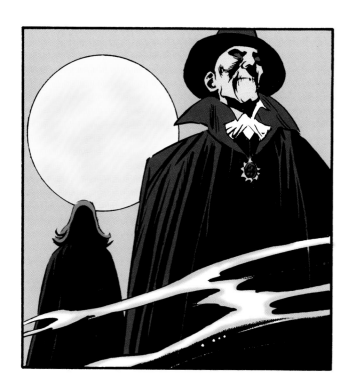

FOREGROUND/BACKGROUND

Foreground/background dynamics are clearly at play here. Note how imposing the closer figure is due simply to the fact that he's in the foreground. The classic technique is to place the foreground and background figures or objects at opposite corners of

the panel diagonally across from one another. Here, the woman's head is near the lower left corner and the man's is near the upper right corner. In addition, the low angle, dark costumes, and use of silhouette also contribute to the foreboding feeling.

Note that the man and the woman *overlap* each other, which ties them

together more effectively in the scene and creates a greater feeling of depth. Also note that the man bleeds out into the right wall of the panel, while the woman is totally within the panel; in this way, the spacing is asymmetrical and this heightens the visual interest.

POINT OF VIEW

Again, foreground/background dynamics are working overtime. She is in the foreground with the unicorn in the distance. A high angle creates the feeling that the woman is looking down at the unsuspecting animal. You can tell that we're seeing things from *her* point of view, because we're looking directly at her but down at the unicorn. She is cut off by the panel,

but the unicorn appears within the panel borders, which adds to the asymmetry. Unlike the figures in the previous panels, the girl and the unicorn do not overlap; that would tie them together too closely for what this scene is trying to establish—she is, after all, spying on the animal.

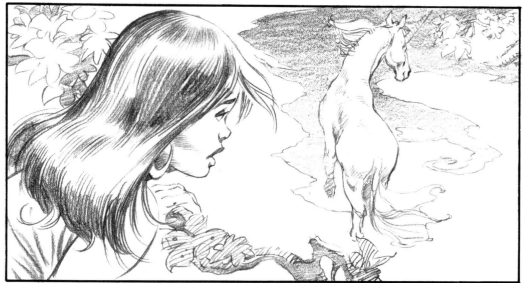

POINT OF FOCUS

In every good panel there's always an object of focus—the thing that draws your attention, the point of the scene. In the panel at right, the point of focus is the object the Neanderthal character is smashing—this is highlighted because both figures are looking at that object, and the tree leads into it.

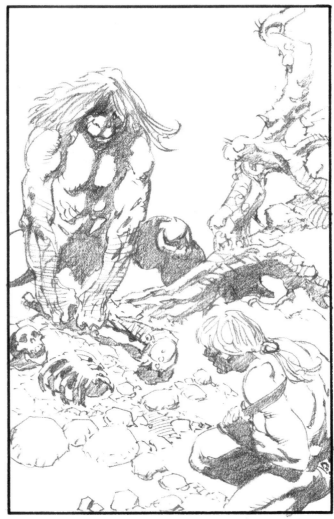

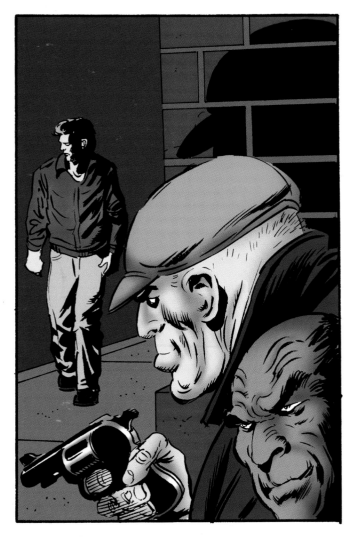

ANTICIPATION

The object of focus in this panel is the unsuspecting man and the gun, which are both purposely positioned in the same half of the panel, as if the man were going to walk right into the weapon. There's a feeling of inevitability about the scene, and as this panel demonstrates, it's essential to set up a conflict before it actually occurs. This creates the all-important feeling of *anticipation*, which makes readers become more invested in the story.

Storytelling: Types of Shots

The ability to tell a story visually is the most important task for the comic book artist. Each panel should lead logically and emotionally to the next, creating suspense, pacing, and excitement. Here are a number of types of panel shots you can use to achieve this.

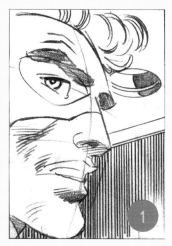

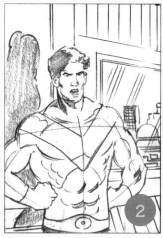

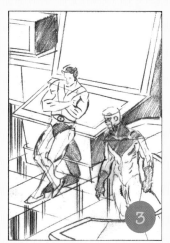

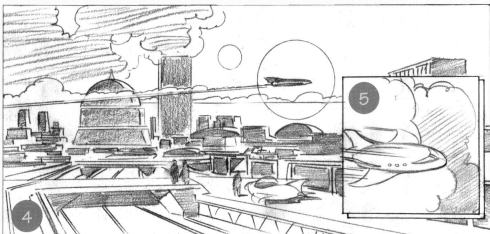

1. THE CLOSE-UP SHOT
tells us that something important is happening, and is a good shot to use to register a character's reaction. It also breaks up the pacing and keeps the story from getting monotonous.

2. THE MEDIUM SHOT
is a good transitional shot to use to move into or out from a close-up panel. Use this when you want to get close enough to see facial expressions but when using a narrow close-up shot would eliminate some valuable visual information such as the background.

3. THE PULL-BACK SHOT
reminds the reader of what's going on in the entire scene.

4. THE ESTABLISHING SHOT
gives the reader an expanded look at the surrounding area, whether it is a city, landscape, or the interior of a room.

5. THE INSET PANEL
is a detail of what's going on inside a section of a wider shot (in this case the airplane).

6. THE GROUP MEDIUM SHOT
is the same as the medium shot, only with more figures.

7. THE GROUP CLOSE-UP SHOT
is the same as the close-up shot, again only with more figures.

8. THE GROUP PULL-BACK SHOT
(or group full-figure shot) serves the same purpose as the regular pull-back shot, again with more figures.

Putting It All Together

By using all of the composition techniques we've reviewed, you can seamlessly string together a consecutive series of panels in a way that most effectively communicates what's happening.

1. THE ESTABLISHING SHOT
is used to convey the height of the building.

2. THE MEDIUM SHOT,
with the hero entering, serves as a good transition for the next panel.

3. THE CLOSE-UP SHOT
is used to register emotions through intense facial expressions.

4. THE MEDIUM SHOT
shows the hero's reaction to the woman running toward him.

5. THE ESTABLISHING SHOT
shows the city, the new character, and the crowd's reaction.

6. THE CLOSE-UP SHOT
bonds the hero and woman together. Their love is so strong, it's as if the rest of the world has disappeared—and in fact, it temporarily has.

7. THE LOW ANGLE CLOSE-UP SHOT
indicates awe at the thing they are witnessing.

8. THE PULL-BACK SHOT,
which acts here as an establishing shot, shows a bird's-eye view of a rocket ship soaring over the city. This re-establishes the setting and the action, and leads to the next panel.

9. THE MEDIUM CLOSE-UP SHOT
shows the hero and woman reacting.

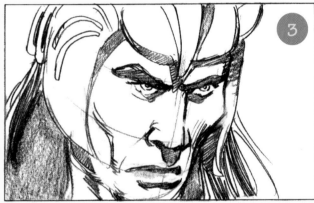

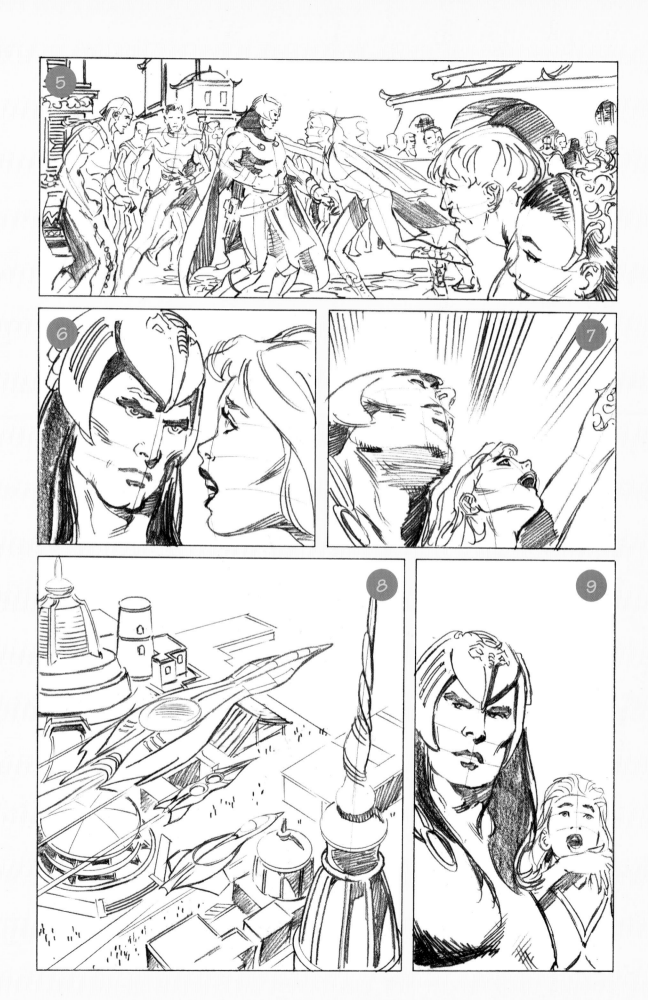

Where Evil Lives: Backgrounds for Bad Guys

Bad guys and gals need a place to hang. Libraries and malls just won't do the trick. Here are a few classic locations that work well to kick off a story for your more nefarious characters.

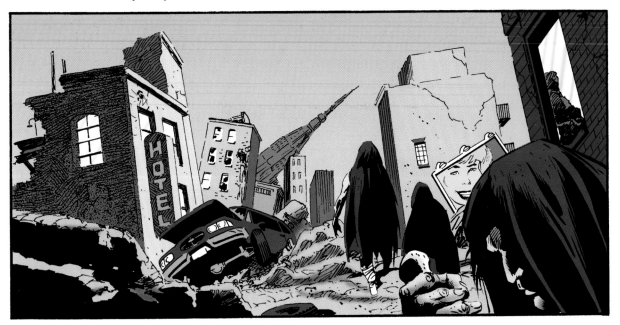

POSTAPOCALYPTIC EARTH

What a mess. What causes an apocalypse? Biological warfare, nuclear explosions, collisions with gigantic meteors, volcanoes, armies of invading aliens with a taste for human flesh, and monster earthquakes to name a few. In a world governed not by the rule of law but by the law of survival of the fittest, bad guys and gals are—unfortunately for those who survive—usually the fittest of them all.

EVIL SCIENCE LAB

No, he's not searching for the cure for cancer. He's looking for what causes pain. And he's probably making really good headway. What exactly does this machine do? Doesn't matter—as long as it hurts. You don't need to be specific. A few beads of sweat from the good guy, and your readers'll all get the picture. Keep in mind that when your bad guy wants the good guy to talk, but he won't, you can't just have the bad guy kill the good guy, because then the story would be over. The bad guy has to torture him, and then he has to stupidly leave the room, confident that the good guy can't possibly escape, which, of course, he does. Hey, some things never change.

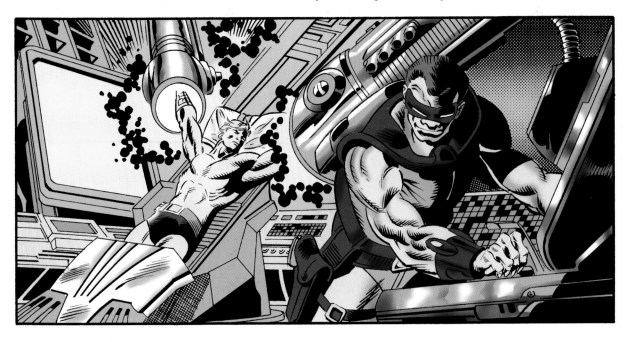

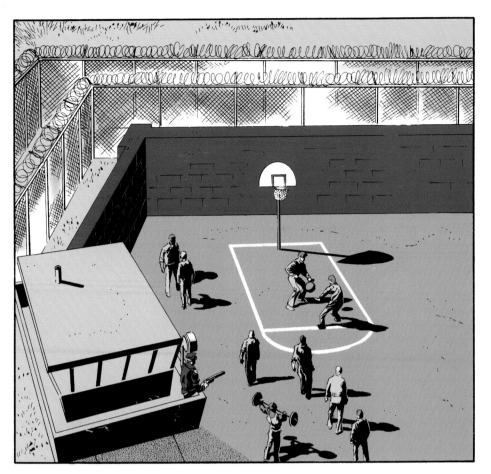

PRISON COURTYARD

A shot of a prison immediately lets the reader know that we're dealing with the baddest of the bad, and a prison courtyard is an excellent place to begin. A courtyard fight is inevitable, and the victor is presumed to be the toughest bad guy around. In this way, you'll have quickly established who is to be feared. By establishing this right off the bat, you don't have to work so hard later in the story to convince the reader that your bad guy is dangerous.

Typically, a bad guy doesn't remain in prison for long. A crooked politician might arrange to have him released, for example. Once out, the bad guy hooks up with his benefactor, who might be the mad genius who bribed the crooked politician. Perhaps the mad genius needs the criminal skills and brute force that the bad guy offers. Remember, every mad genius has a plan to destroy the world. Note that long shadows add to the hard, bleak feeling of a prison courtyard scene.

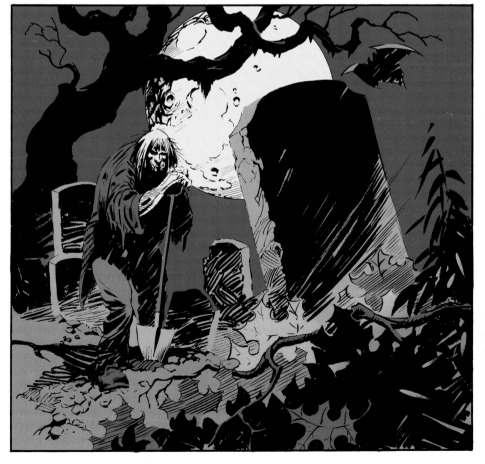

CEMETERY

The undead dead are pretty happenin' characters in comic books. Oh sure, they may lose a limb here or there due to rigor mortis, but other than that and a few pesky larvae, they're in pretty good shape. Where do you go to recruit the undead dead guy for your mob of bad guys? The cemetery, of course. It's your one-stop undead shopping head-quarters. A cemetery is usually depicted at night, complete with a full moon, wind-whipped leaves, owls, bats, and silhouettes of tree branches that reach out like the skinny hands of an old witch.

INDEX